Great new ways to ~~paint~~
Glas

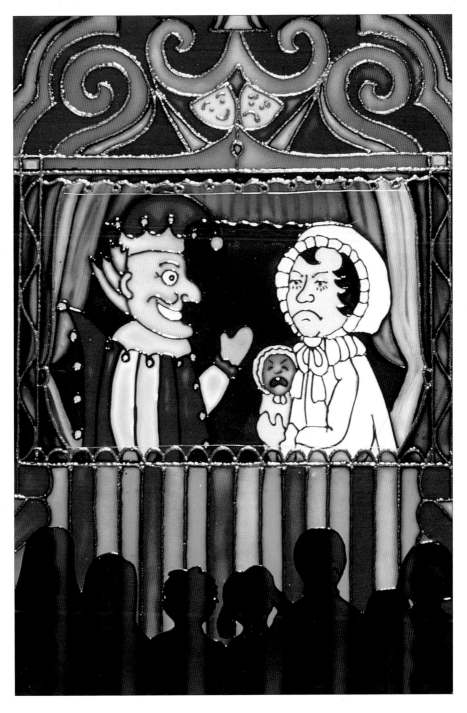

Great new ways to paint on
Glass

Julia Bottrell

SEARCH PRESS

First published in Great Britain 1999

Search Press Limited
Wellwood, North Farm Road,
Tunbridge Wells, Kent TN2 3DR

Text copyright © Julia Bottrell 1999

Photographs by Search Press Studios
Photographs and design copyright © Search Press Ltd.
1999

ISBN 0 85532 883 5

Suppliers
If you have any difficulty in obtaining any of the
materials and equipment mentioned in this book, then
please write to the publishers at the above address for a
current list of stockists, which includes firms who operate
a mail-order service.

The author would like to thank the following companies
for the supply of materials used to produce the projects
included in this book:
Philip & Tacey Ltd., Andover, Hampshire
Pebeo UK Ltd., Southampton, Hampshire
Verdant Image Ltd. (Maimeri), Leicester
Eberhard Faber UK, Wales
Jim MacDonald (Picture Framing), Andover, Hampshire

Publisher's note
The step-by-step photographs in this book feature the
author, Julia Bottrell. No models have been used.

Colour separation by P&W Graphics, Singapore
Printed in Spain by Elkar S. Coop. Bilbao 48012

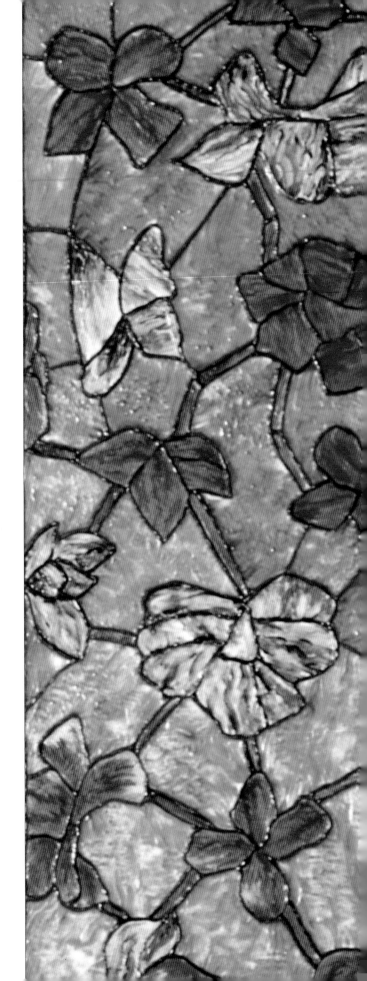

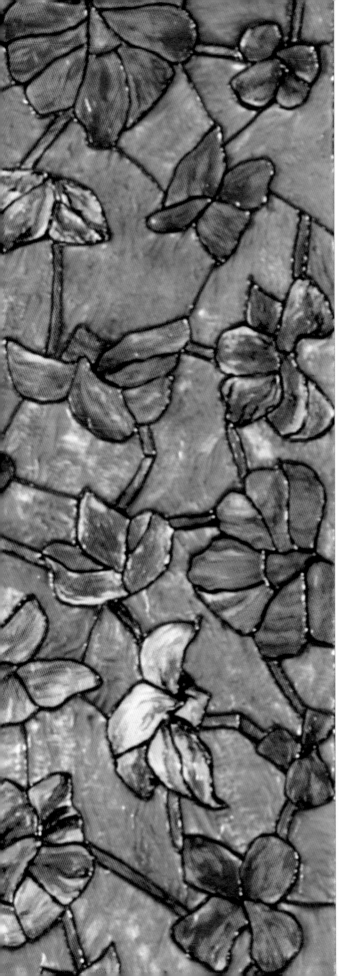

Contents

Introduction

Until recently, you needed special skills to work with glass. Stained glass artists created beautiful works of art in ancient Roman temples and the great cathedrals of Europe, enthralling congregations with the luminosity and translucency of the rich colours. Now, there are many new paints and materials available in an exciting range of colours and textures. They are easy to use, and stunning effects can be achieved without any effort - and without special skills. This book shows you how, using projects and easy-to-follow photography.

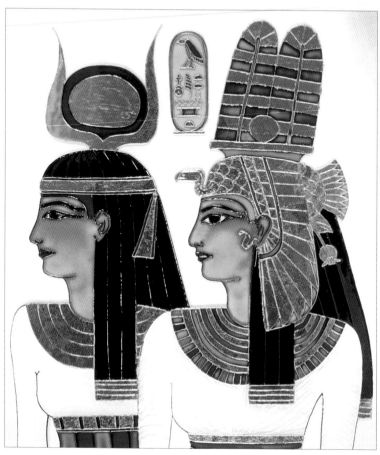

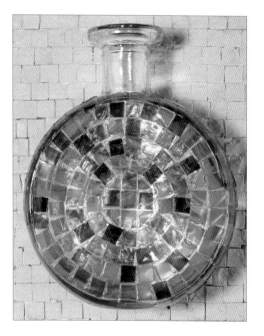

Since I wrote *How to Paint on Glass*, many new non-toxic products have become available. Glass surfaces can be decorated with translucent and opaque paints, metallic outliner, Dutch metal leaf, frosted varnish, mosaics, stencils and textured gel. Pictures, bottles, vases, plates and bowls can all be enhanced, either using just one or several different techniques together. The book starts with the basic outlining and painting method; this is followed by projects illustrating

how to create frosted effects, three-dimensional pictures, leaded panels and a gilded box. I work through to more advanced challenging designs including a mosaic bottle, and textured gel designs.

Many people are interested in transforming plain windows and doors, and I have featured different ways to do this. I have developed an easy technique for painting vertically on existing glass surfaces and I also show how to use self-adhesive lead to fix panels to existing windows.

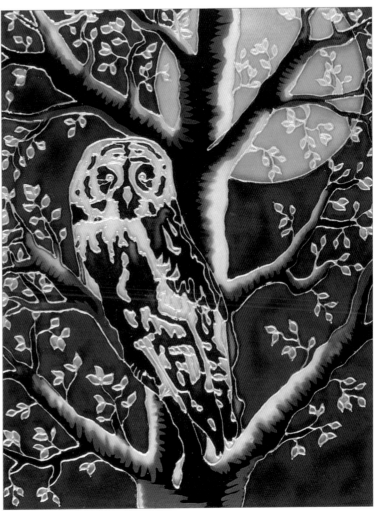

Finally, because I believe in making things as straightfoward and as simple as possible, I have included all my tips, techniques and short-cuts, which will give your projects a more professional finish.

I hope you will all have many hours of fun with my *Great new ways to paint on glass!*

Materials

The picture opposite shows the basic materials and tools used for painting on glass. There are also a number of other materials that can be used with the other techniques included in this book, and these are shown at the beginning of each chapter.

Painting surfaces

You can paint on sheets of glass, clear plastic and acetate, and on plastic or glass boxes and bottles.

Sheet glass is less expensive than plastic and will not mark or scratch easily. However, plastic is safer to use as it is lighter in weight and will not shatter. Thin sheets of acetate can be cut, bent and painted.

There is a wide variety of plain glass and plastic bottles (blanks) available from craft shops. However, many gifts and chocolates are packaged in clear boxes, and it is worthwhile saving these for future projects.

Paints

Water- and solvent-based glass paints are available. However, all the images in this book were painted using the water-based range. I prefer these paints for a number of reasons. They are non-toxic and odour free, so you do not have to work in a well-ventilated room. There is now a wide range of colours to choose from. They are perfectly safe for children to use. They are cleaner and easier to use – brushes and spills are simply cleaned with water.

Paint brushes

I only use synthetic fibre brushes. I find that they perform equally as well as sable-haired brushes. You will need a range of sizes – I use sizes 8 and 10 for general work, and sizes 4 and 00 for detail. Choose brushes that have fine tips.

Deep-welled palette

Glass paints have a runny texture so a deep-welled palette is best for keeping colours separate and contained.

Pipette

Use a pipette to decant paints – pouring paint from the bottle can cause drips and spills. A pipette is also used for painting large areas. (See page 32)

Paper

Use tracing paper for making templates. Cover your work top with plain white paper so that you can see the image on the glass more clearly.

Felt-tip pen

Use a felt-tip pen to trace your template. Use a colour that contrasts with the outliner.

Outliner/gutta nib

Outliner is used to draw enclosed areas of the design before painting. For normal work, outliner is applied straight from the nozzle. For fine work, a size 0.9mm gutta nib can be fitted on to the nozzle of the outliner tube.

Craft knife

A craft knife is a useful addition to any work box.

Cotton buds

Cotton buds are invaluble for mopping up mistakes.

Cleaning fluids

Painting surfaces must be thoroughly cleaned with a good quality glass cleaner or nail varnish remover (acetone) before you start to paint. This is particularly important when using plastic or acetate as it will reduce static electricity which attracts dust particles. Do not use white spirit.

Paper towel

Used with cleaning fluids for cleaning glass or plastic.

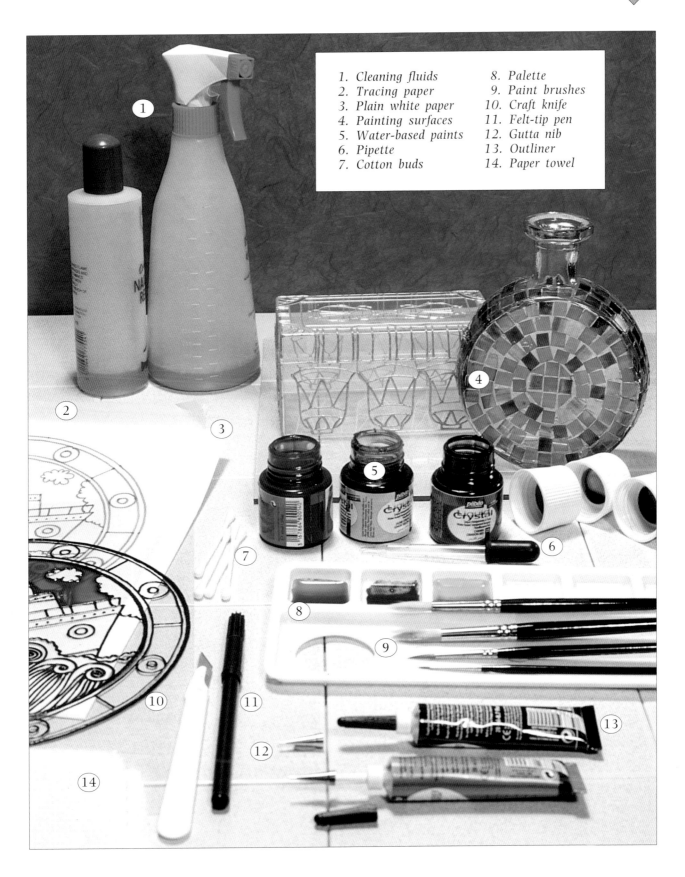

1. Cleaning fluids
2. Tracing paper
3. Plain white paper
4. Painting surfaces
5. Water-based paints
6. Pipette
7. Cotton buds
8. Palette
9. Paint brushes
10. Craft knife
11. Felt-tip pen
12. Gutta nib
13. Outliner
14. Paper towel

Basic techniques

Ship through a porthole

In this first project, I show you the basic techniques used for glass painting. These include making a template, using outliner (liquid lead), and painting with water-based glass paints. I have also included a number of tips that may help you achieve a more professional finish to your glass painting projects.

Materials

The tools and materials used for this project are descibed and illustrated on pages 8–9. I used black outliner and blue, red, green, white and black glass paints.

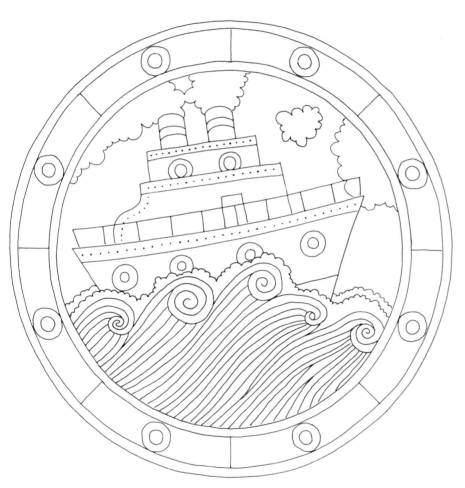

Use this pattern to make a template. You can enlarge it to any size you like, but for the finished painting on page 16, I enlarged it to 200%.

Making a template

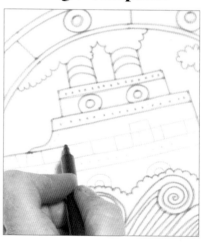

Enlarge the pattern to size and then use a felt-tip pen and tracing paper to make a template. Use a pen colour that contrasts with the outliner you intend to use. This will help avoid missing out any of the design.

Applying outliner

Place the template face up on plain white paper and secure to the back of a sheet of glass. Pierce the nozzle of a tube of outliner with a long pin or needle. Squeeze the outliner tube gently to start drawing in the design. Unless stated otherwise, hold the nozzle at an angle of 45°.

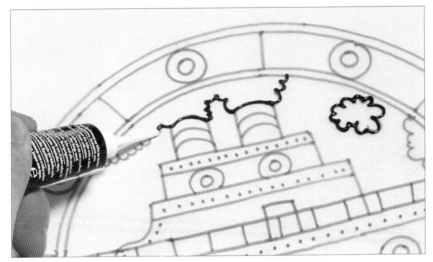

Outliners

When you are learning to paint on glass, start with a black outliner as this has a firmer texture than the metallic ones.

Practise your outliner technique on scrap pieces of acetate until you are satisfied with your line control.

Place tubes of outliner in a refrigerator for an hour before use. This will make the liquid less runny and easier to use.

Short curved lines For outlines such as those of the clouds and smoke, press the nozzle on to the glass, squeeze the tube gently and work one curve at a time.

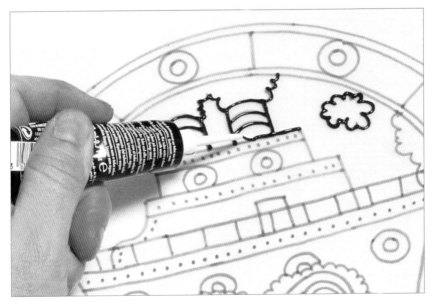

Straight lines Anchor the outliner at one end of the line and then, keeping the nozzle slightly up off the glass, gently squeeze the tube and allow the outliner to fall into place. This really is easier than it sounds.

Small circular shapes Work these with two applications. Start at the top and work a semicircle of outliner. Then go back to the top of the shape and fill in the other half.

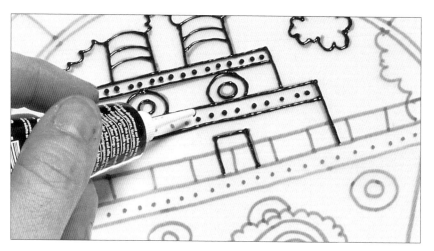

Dots Apply slight pressure to the tube, touch the tip of the nozzle on the glass and then lift it off to leave a tiny bead of outliner.

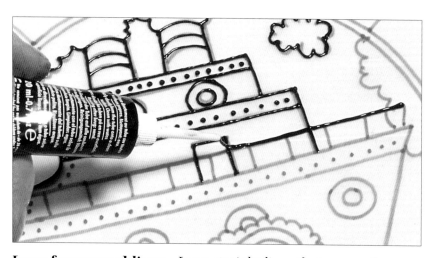

Long foreground lines Long straight lines that cross other parts of the leaded design should be continuous. Lift the outliner when crossing intersections.

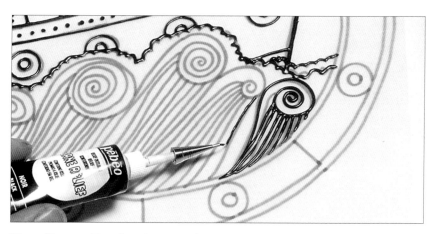

Fine lines For fine line work use a 0.9mm gutta nib, pushed on to the tip of the nozzle of the tube of outliner. You do not have to cut the nozzle when fitting nibs.

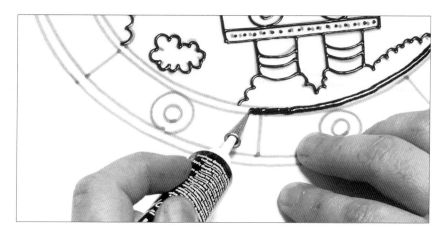

Wide lines A 0.9mm gutta nib can also be used to make wide lines. Place the nib flat on the glass, at right angles to the line to be drawn. Squeeze the tube until the line is the correct thickness, then slowly move the nib sideways to draw the line. Work short sections at a time and turn the glass as necessary.

Check for gaps When all the lines on the template have been drawn with outliner, remove the template and check for any bad joins. All areas of the design must be fully enclosed to stop paint leaking out. Repair gaps with small beads of outliner.

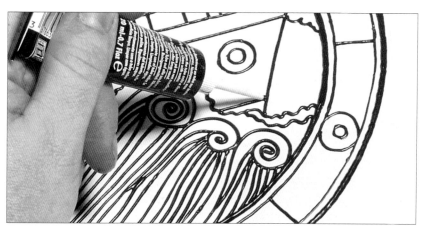

Correcting errors

Sometimes you will make a mistake and the outliner will end up in the wrong place.

Correct such errors immediately using a clean cotton bud. Simply move the offending length of outliner to the correct position and wipe away any excess.

Starting to paint

I suggest you work with one colour at a time, and fill in each enclosed area in turn. Turn the work as necessary so that you do not lean over wet areas. Do not worry if the paint touches the outliner – water-based paints will not stain it. Even if you choose to use solvent-based paints, they will not show against a black outliner. I used five colours to paint this design, diluting each with varying amounts of water to obtain different shades.

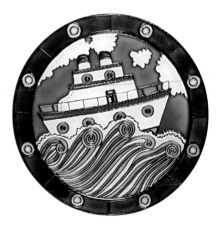

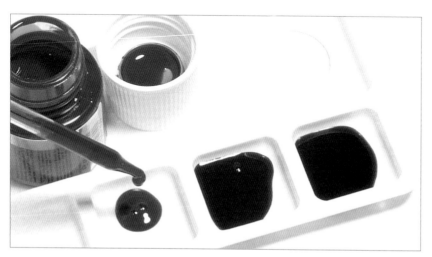

Decant paints Use a pipette to transfer paint from the bottle to the palette.

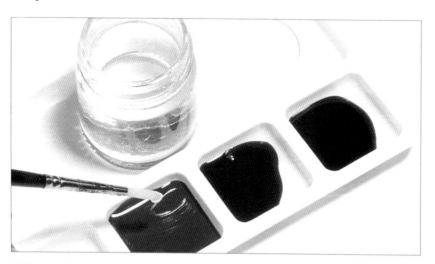

Dilute the paint Add water to the paint to achieve a good consistency and the shade you require.

Paint consistency

Neat paint can be rather too thick to work with. Thick paint looks very glossy and clings to the brush.

The best consistency is when a small blob forms on the end of a loaded brush.

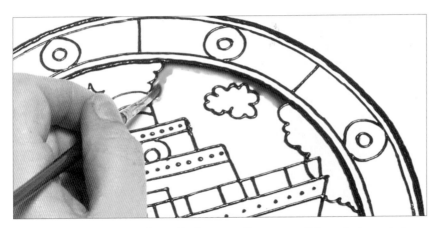

Paint round an enclosed shape Use a small brush to paint round the outer edge of an enclosed area. Work the paint right up to, but not over, the outliner.

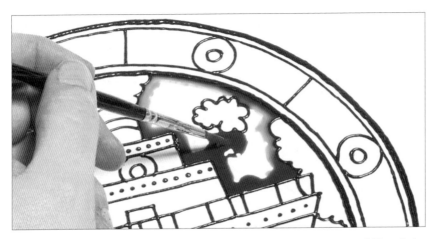

Reload the brush Place a large blob of paint in the middle of the outlined area.

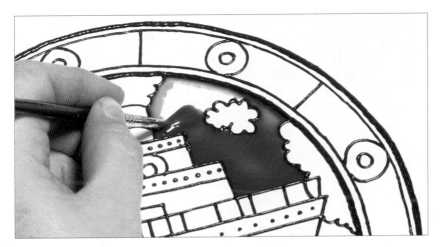

Fill in the enclosed area Gently push the paint across the enclosed area until it is completely covered.

Wipe up any spills

Use a cotton bud to remove any spills outside the enclosed area.

Remove surplus paint

Hold a cotton bud in a pool of colour to remove excess paint.

Remove bubbles

It is difficult to stop bubbles forming on the painted surface when using water-based paints. Air gets into the paint when it is diluted and bubbles are carried over in the brush. Gently push bubbles to the edge of the painted area where many will disappear. Use the brush handle to burst any stubborn ones.

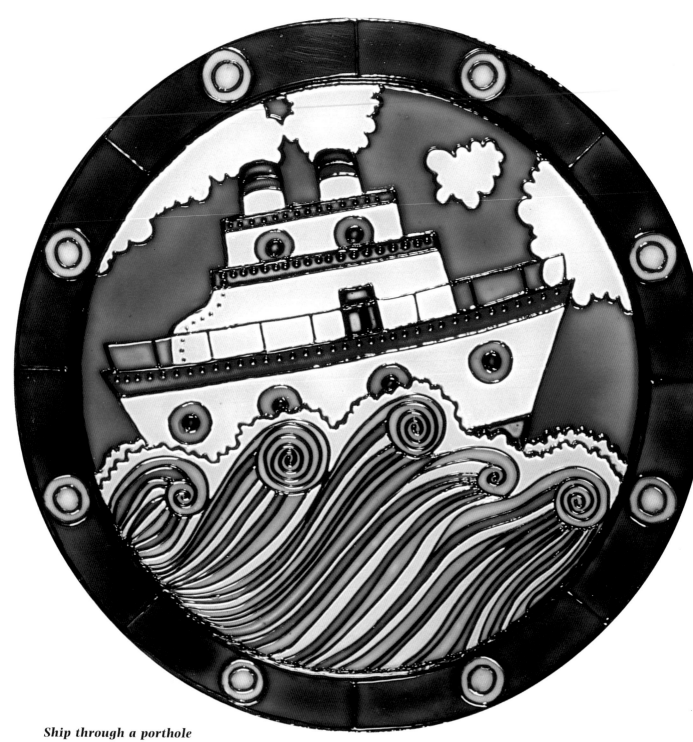

Ship through a porthole

This picture was painted on a square sheet of glass using black outliner and five different colours of water-based glass paints. The painted image is 240mm (9¹/₂in) in diameter.

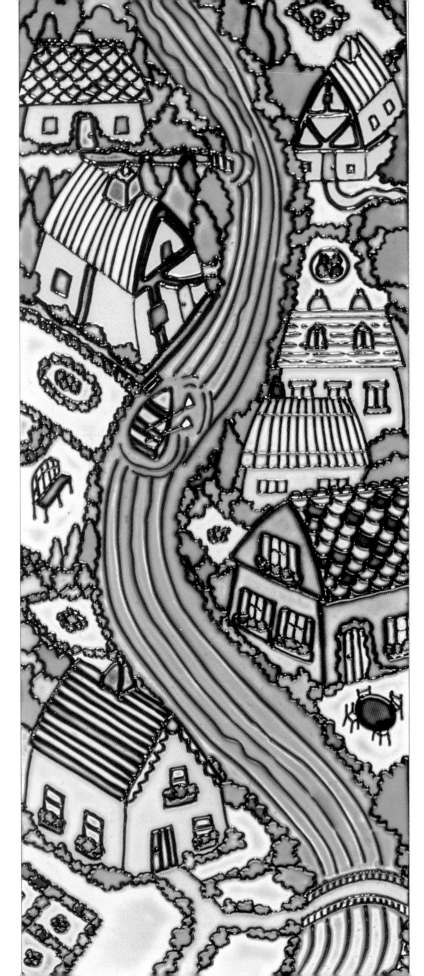

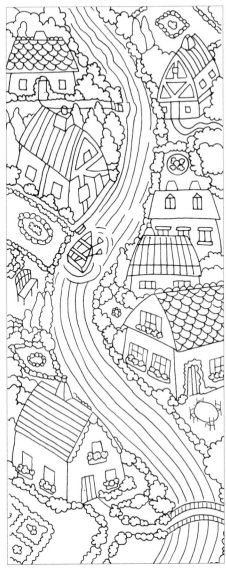

Winding river

This unusual subject for glass painting provides the perfect opportunity to show off your line work. It was painted using the techniques shown in this chapter. The finished painting on glass measures 170 x 420mm (6³/₄ x 16¹/₂in). Enlarge the pattern to 280% for a full-size template.

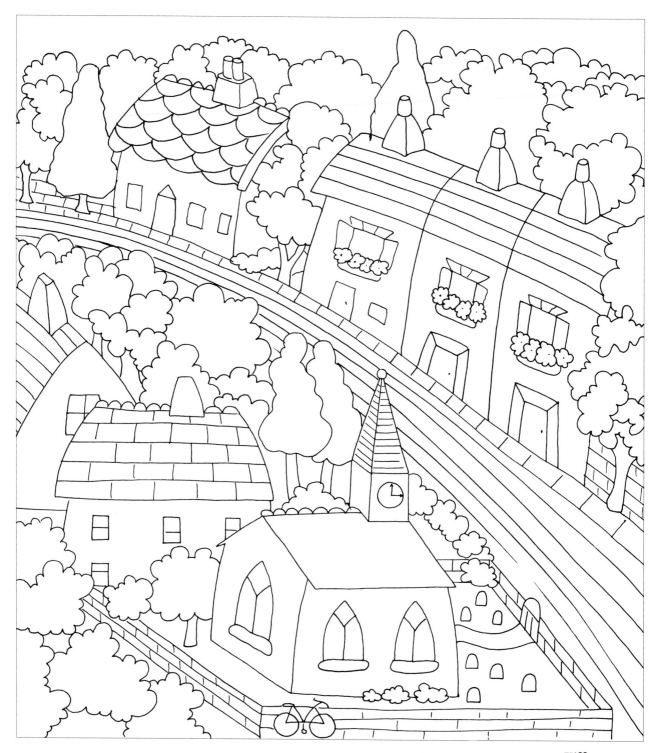

Village scene

This design, a companion to that on page 17, was painted on a 255 x 285mm (10 x 11¼in) sheet of glass. Both designs would be effective as door panels (see pages 72–79) or as suncatchers. Enlarge the pattern to 150% to make a full-size template.

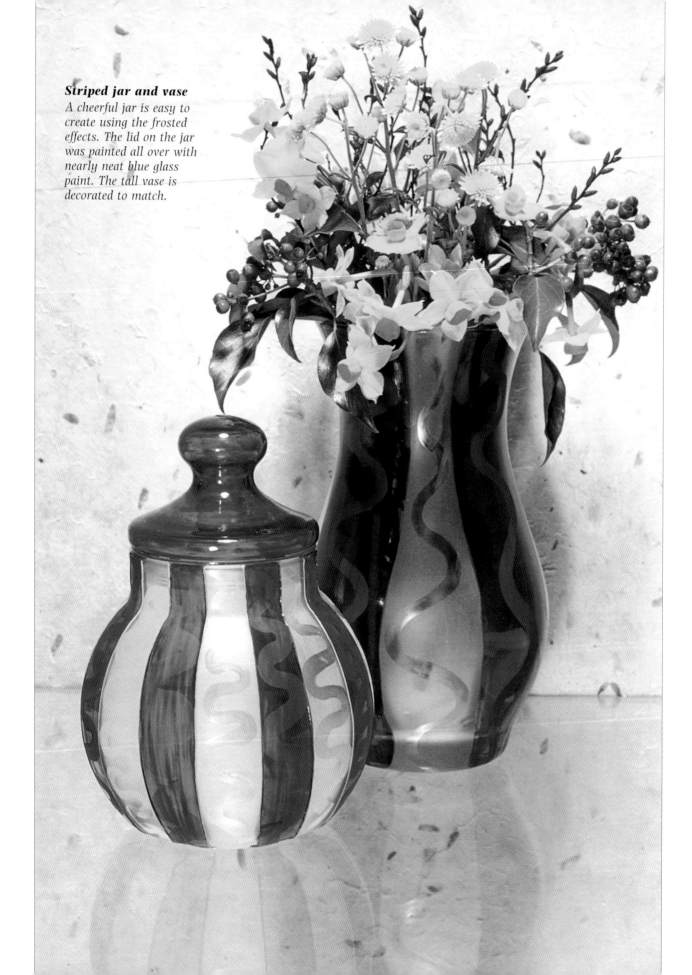

Striped jar and vase

A cheerful jar is easy to create using the frosted effects. The lid on the jar was painted all over with nearly neat blue glass paint. The tall vase is decorated to match.

Frosted effects

Striped jar

Matt varnish can be used to create beautiful frosted effects. When dry, it looks just like acid-etched glass. When gloss varnish is then painted over the dry matt varnish, the painted areas become clear again. Dilute matt varnish with a little water to help achieve a smooth finish. When applying matt varnish, do not worry about overlapping layers – when it dries the surface will appear even.

In this project I have combined both types of varnish with gold outliner and blue glass paint for a simple yet stunning result that is easy to achieve. When painting the blue stripes take care not to touch the gold metallic outliner – unlike black, which is glossy and repels paint, gold has a matt finish which will mark.

Materials
The special materials needed for this project are water-based matt and gloss varnish, and a tube of gold metallic outliner. Clear glass jars and vases are readily available.

1. Divide the top of the jar into an equal number of divisions. Then, use a felt-tip pen or china-graph pencil to draw vertical lines down the side of the jar.

2. Use gold outliner to draw lines down the jar, just to one side of the guide lines.

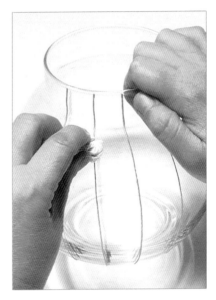

3. When the outliner is thoroughly dry, use a damp paper towel or cotton bud to remove the guide lines.

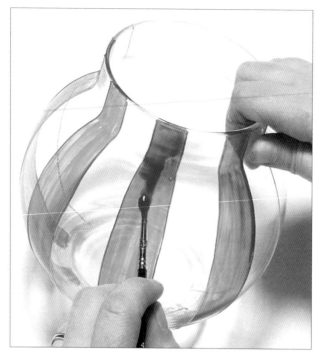

4. Paint alternate stripes using nearly neat blue glass paint. Leave to dry then overcoat with more layers to achieve the required depth of colour.

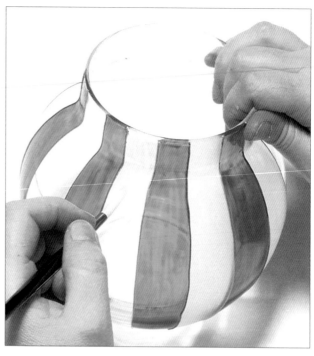

5. Paint the other stripes with matt varnish and leave to dry.

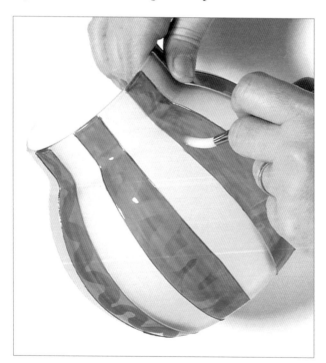

6. Decorate the blue stripes with squiggles of matt varnish. When dry, apply a second coat to create a more marked effect.

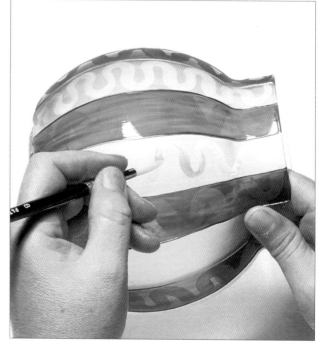

7. Finally, decorate the frosted stripes with squiggles of gloss varnish. When dry, apply a second coat to the design for greater effect.

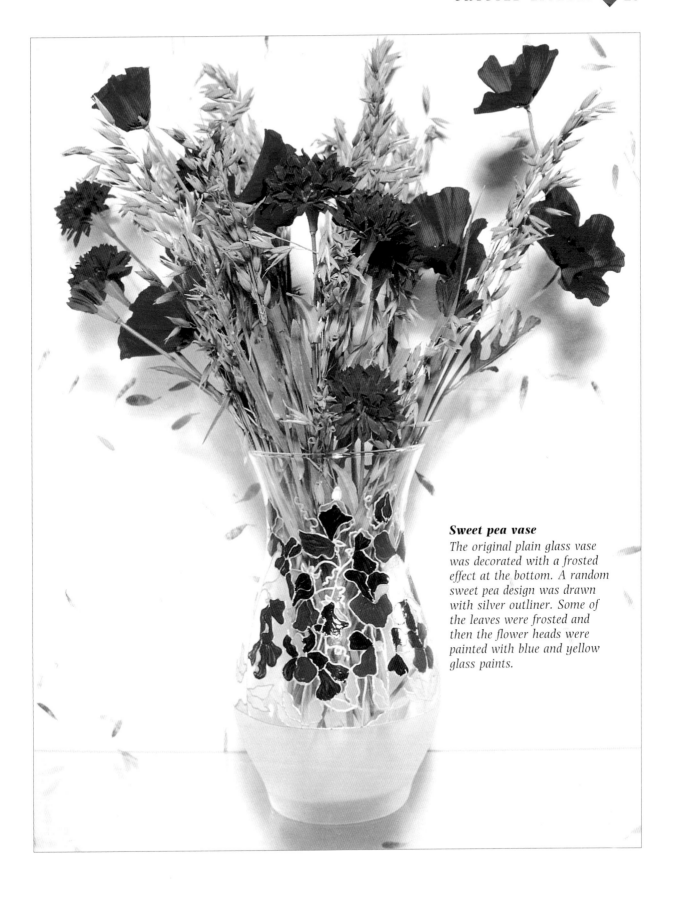

Sweet pea vase

The original plain glass vase was decorated with a frosted effect at the bottom. A random sweet pea design was drawn with silver outliner. Some of the leaves were frosted and then the flower heads were painted with blue and yellow glass paints.

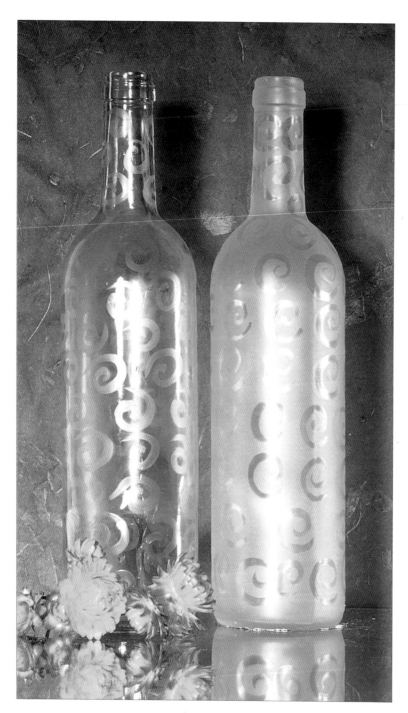

Frosted bottles and vase

Left: Matt and gloss varnish decorate these clear glass bottles. The left-hand bottle was painted with simple squiggles of matt varnish. The right-hand one was first covered with a coat of matt varnish. When this was completely dry, the surface was overpainted with squiggles of gloss varnish.

Opposite: The two bottles in this picture were decorated with matt varnish. The vase was first decorated with a random design drawn with silver metallic outliner. Then the enclosed areas were filled with glass paint. Finally, all the background area was painted with matt varnish.

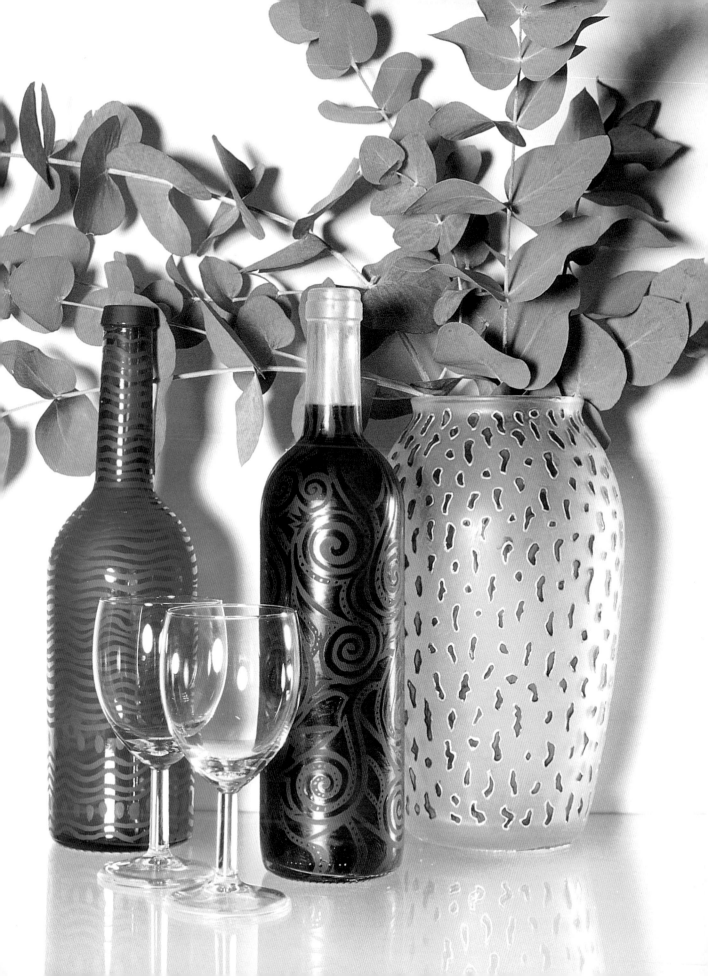

Night owl

This design was given a frosty night atmosphere by using matt varnish on the leaves, tree trunk and branches, parts of the owl and on the lemon-painted moon. Silver metallic outliner adds to the dramatic effect. The panel is painted on glass and measures 255 x 335mm (10 x 13¼in). Enlarge the pattern to 175% for a full-size template.

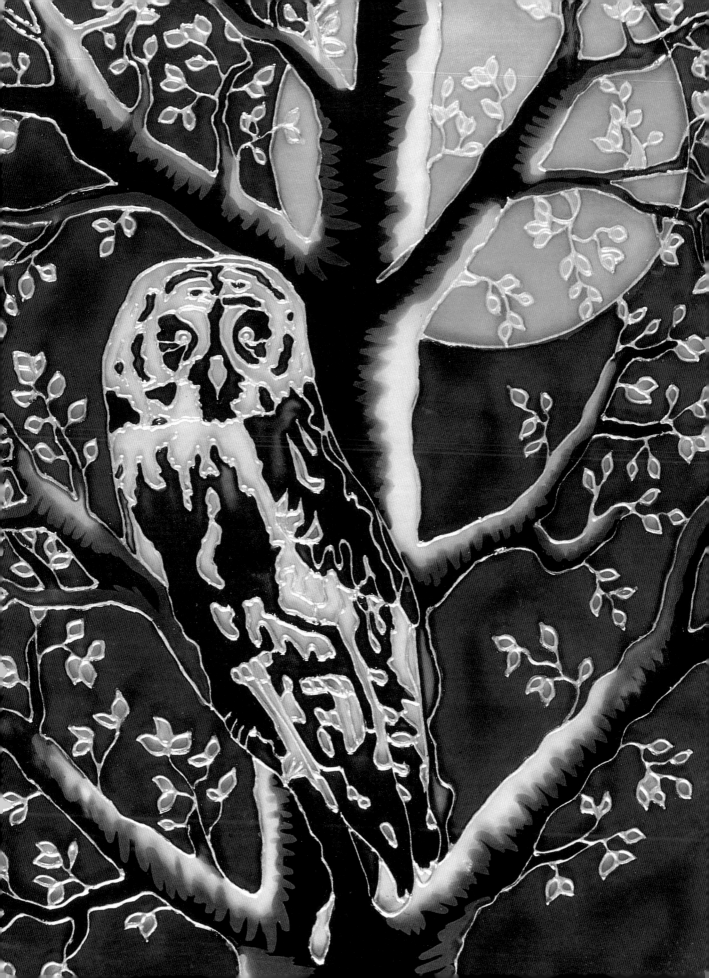

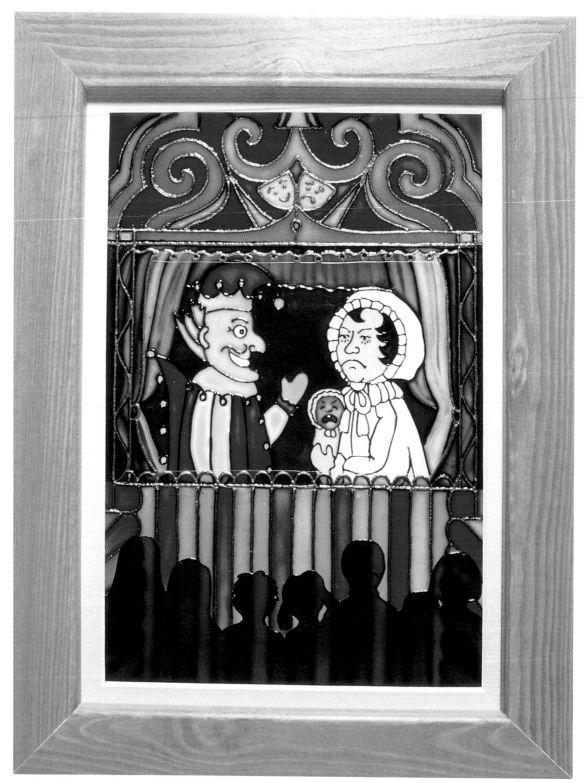

Punch and Judy show

The finished project has a painted image area of 180 x 265mm (7 x 10½in).
Enlarge the patterns opposite to 300% for a full-size template.

Three-dimensional pictures

Punch and Judy show

You can create beautiful three-dimensional pictures using a simple technique. Sheets of acetate are painted and then layered together with thin strips of foam board between each sheet. The sandwich is then covered with a mountboard and fastened inside a picture frame, without a backing board. Remember that the sheets of acetate must be sized to fit in the recess at the back of the frame, and the opening in the mountboard must be sized to the edge of the design. Hang the finished picture in a window and enjoy the view.

I also introduce you to two new painting techniques: blending colours wet into wet, and diluting paint with gloss varnish, instead of water, to retain a strong density of colour.

Materials
The special materials needed for this project are a ruler, foam board, a black felt-tip pen, a pair of scissors, general-purpose glue, masking tape, mountboard and a picture frame.

Pattern for the middle layer. It must be painted on a full sheet of acetate that is sized to include borders.

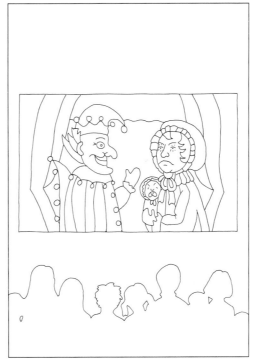

Pattern for the bottom layer. This must be painted on a sheet of acetate the same size as the middle layer.

Pattern for the top layer. Paint this on a small piece of acetate, the same width as the sheets for the middle and bottom layers.

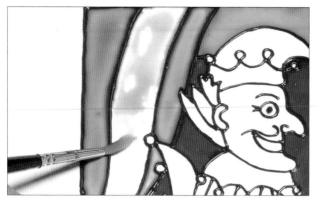

1. Use black outliner to draw the bottom layer on a sheet of acetate. When this is completely dry, start to paint the enclosed areas. Remember that when working on acetate, the first application of diluted paint may draw back from the edges or leave gaps as shown here.

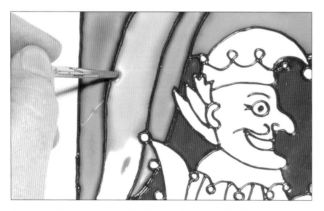

2. Continue to work the paint until the area is completely covered. If gaps persist, add neat paint to make a slightly thicker mix.

3. Add shape to the curtains on each side of the design by blending two colours wet-into-wet.

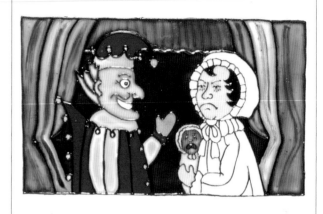

4. Finish painting the background layer using colours of your choice.

> ### *Working with acetate*
>
> *Sheets of acetate generate static electricity which attracts dust particles. If they are not removed, these particles may cause spots in the finished painting. To help overcome this problem, first separate the sheets you want to use and lay them flat on a worktop. Then wipe over both sides of each sheet with glass cleaner and paper towel.*

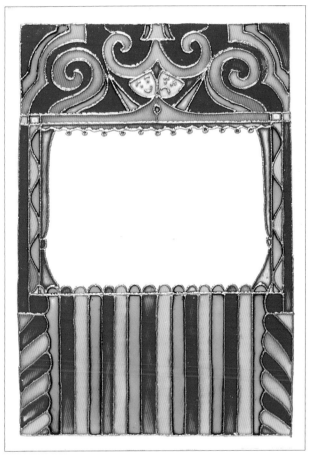

5. Draw the outlines of the middle layer on a sheet of acetate using copper metallic outliner.

6. When the outliner is completely dry, use the basic painting techniques, and colours of your choice, to colour in the show booth.

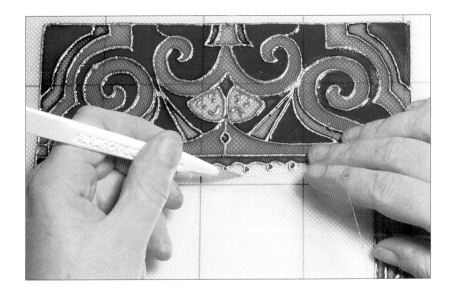

7. When all the paint is completely dry, use a craft knife to cut out the opening in the booth. If you are a perfectionist, you could cut round the intricate shape at the top of the opening, but a simple rectangle will be adequate.

Diluting glass paint with varnish

The top layer of this design is a silhouette of the audience. For maximum impact, the colour needs to be very dark and evenly spread across the whole area. To achieve this, dilute the paint with gloss varnish rather than water.

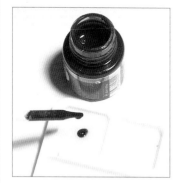

Use a pipette to decant neat paint into a well of varnish.

Stir the mixture with a damp brush. Try to stir very gently – this will reduce the chance of bubbles forming.

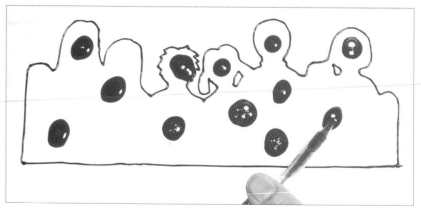

8. Draw the audience with black outliner and leave to dry. Prepare a paint/varnish mixture as shown left and then, using a pipette, gently place blobs of colour across the whole area.

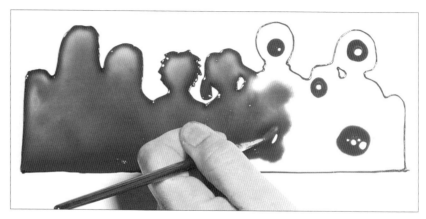

9. While the paint is still wet, use a brush to spread the paint over the whole area. Work gently to avoid creating bubbles.

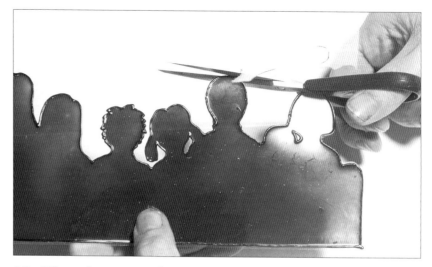

10. When the paint is dry, use a sharp pair of scissors to cut round the outline of the audience.

11. Cut narrow strips of 5mm (¹/₄in) foam board. The width of the strips is determined by the size of the border round the painted design.

12. Colour in the top and one side of each strip with a black felt-tip pen.

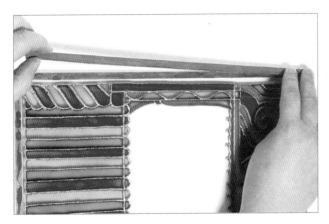

13. Cut the strips to length, then use a general-purpose glue to fix them round the outer edges of both the front and back of the middle layer of acetate. The blackened side of each strip should face inwards. Leave to dry.

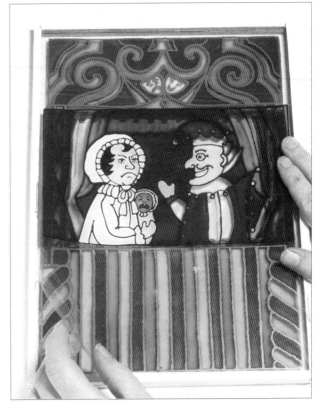

14. Turn the middle layer face down on the work table. Apply general-purpose glue to the foam board strips and then position the bottom layer face down on the strips. Hold the acetate sheet taut until the glue dries, to prevent it sagging on to the middle layer.

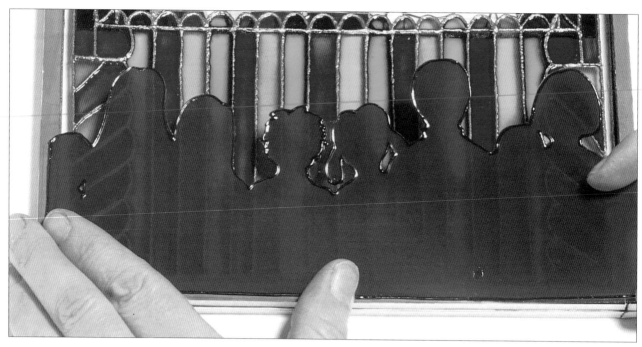

15. Turn the middle and bottom layer sandwich face up, and glue the top layer in position. Again, hold the acetate until the glue dries, to prevent sagging.

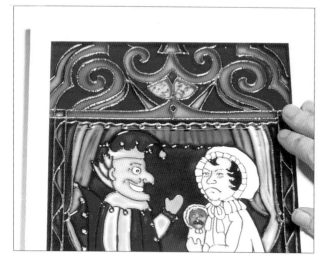

16. Apply general-purpose glue round all sides of the picture and then position the mount board to the front of the painting.

17. Secure the finished picture to the frame with masking tape. Do not worry if the sandwich of acetate sheets and foam strips is deeper than the frame – it is so light that it will not create a problem when hanging the picture.

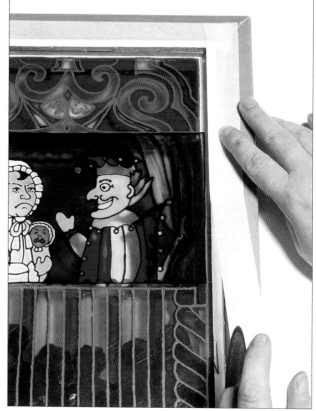

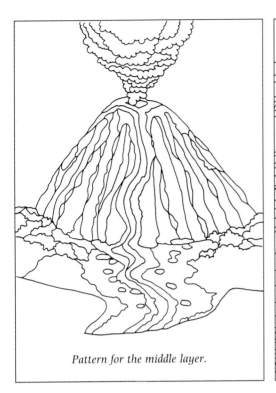

Pattern for the middle layer.

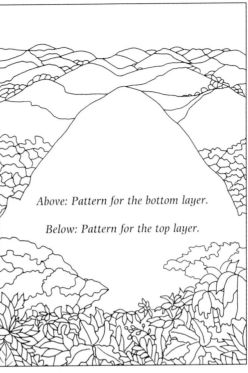

Above: Pattern for the bottom layer.

Below: Pattern for the top layer.

Left and page 37:
Volcano
Standing in the forest, you can watch this volcano erupting in the distance. The bottom and middle layers of this picture were painted on the same size sheet of acetate. The top layer is on a small piece. When sizing these sheets remember to allow borders all round. The image area is 210 x 295mm (8¼ x 11¾in). Enlarge the patterns to 300% for full-size templates.

Right and page 36:
Rose arch
Step through this arch into the garden of this three-dimensional picture. All three layers were painted on the same size sheet of acetate. Again, remember to allow borders all round. The largest painted image area is 210 x 295mm (8¼ x 11¾in). When the paint was dry, the centre of the top sheet was cut round the inner edges of the roses. Enlarge the patterns to 300% for full-size templates.

Pattern for the bottom layer (background garden).

Pattern for the top layer (rose arch).

Pattern for the middle layer (tub of roses).

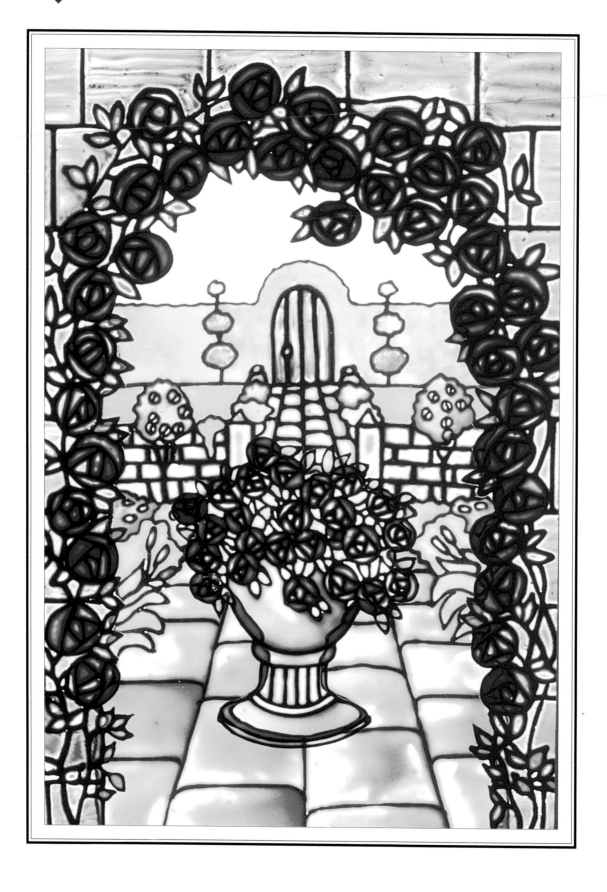

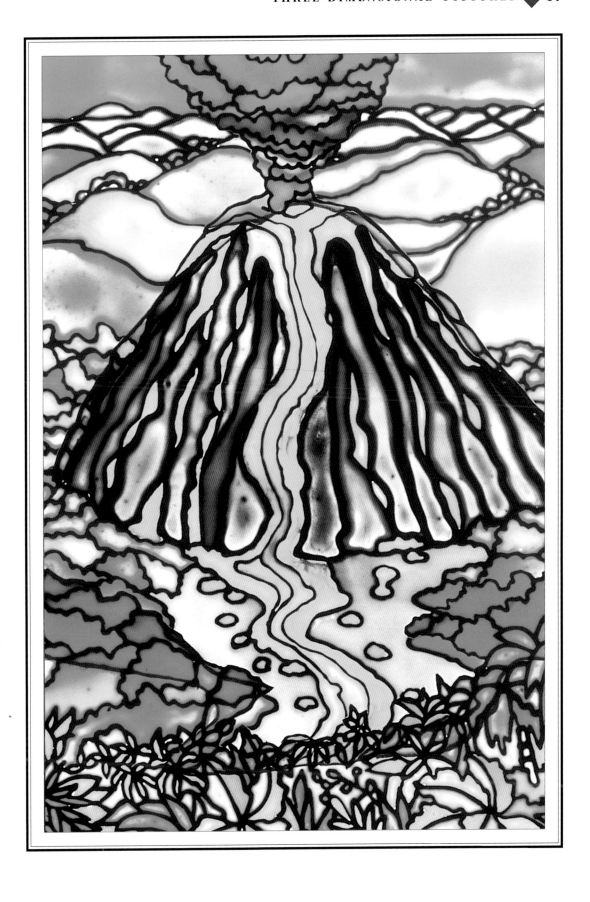

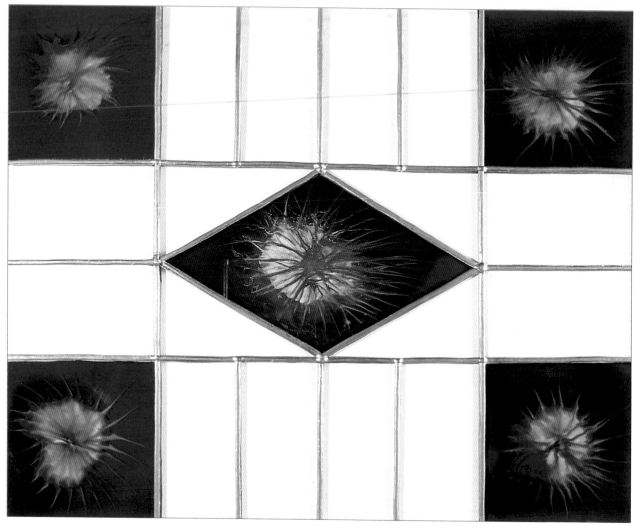

Star-burst window panel

This simple design for a leaded panel has been painted with easy-to-achieve star-burst patterns. The finished panel measures 355 x 280mm (14 x 11in). I have included a pattern which was enlarged to 375% to make the full-size template for this project. However, you should be able to work your own design to fit a specific area.

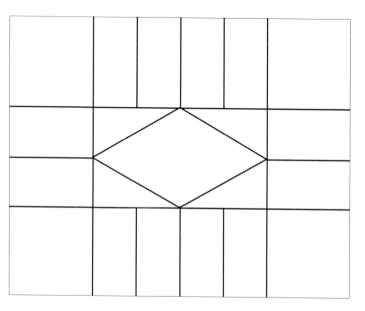

Self-adhesive lead

Star-burst panel

Self-adhesive lead is very easy to apply to glass and it is perfect for creating realistic stained-glass panels in your home. However, lead is a toxic material so I would advise you to wear thin gloves when working with it, or to wash your hands thoroughly afterwards. In this project I also show you how to paint a star-burst glass effect, similar to those that were popular in porch doors in the early 1900s.

Materials

For this project you will need some self-adhesive lead, a burnishing tool, a craft knife, a pair of scissors and some wooden cocktail sticks. Note: the narrow self-adhesive lead used for this project was supplied as a double strip.

1. Secure the template under the sheet of glass and roughly measure the lengths of lead required, allowing a little extra for overlaps.

2. If your lead is supplied as a double strip, cut each length in half through the middle. Angle the ends of each length as necessary to provide neat joints at all overlaps.

3. Apply the lead, working outwards from the centre of the design. Peel back a little of the backing strip, and press one end of the lead to a corner of the diamond shape.

4. Remove more of the backing strip and press the strip of lead down along the line of the template.

5. When the whole length has been positioned, secure it in place by rubbing it well with the burnishing tool.

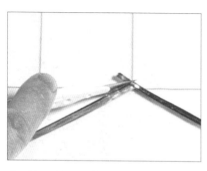

6. Complete the leading of the diamond shape, overlapping each length at the corners. Use a craft knife to neaten up the overlaps.

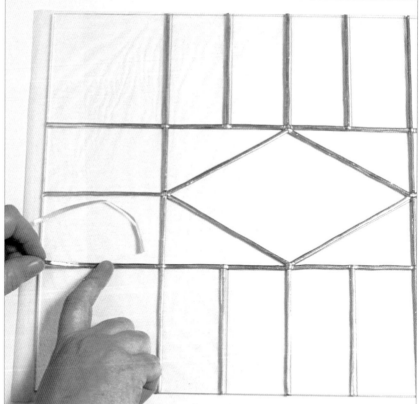

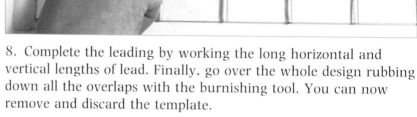

7. Now work the short vertical and horizontal lengths of lead around the diamond shape.

8. Complete the leading by working the long horizontal and vertical lengths of lead. Finally, go over the whole design rubbing down all the overlaps with the burnishing tool. You can now remove and discard the template.

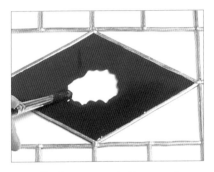

9. Fill the central diamond shape with dark blue paint, leaving a ragged space in the middle of the area.

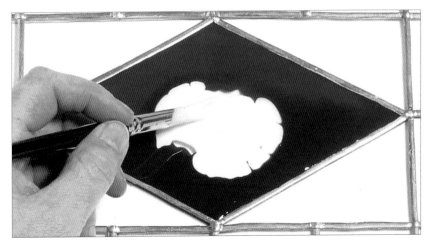

10. Flood the space with neat white paint.

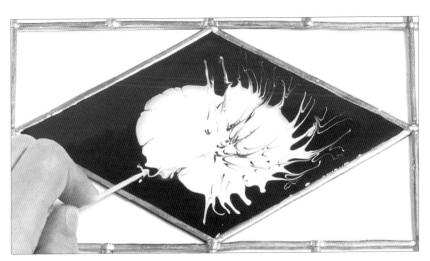

11. Use cocktail sticks to pull the white paint out into the dark blue, and the dark blue into the white.

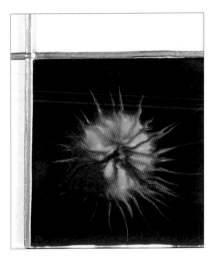

12. Work a similar design with red and white paint in the four corners of the design.

Paint bleeds under lead

No matter how much you burnish down self-adhesive lead, some paint will inevitably bleed under it and be visible on the other side of the panel as shown here. If the panel is to be viewed from both sides, add more leading to the back of the panel, making sure that you match the design exactly.

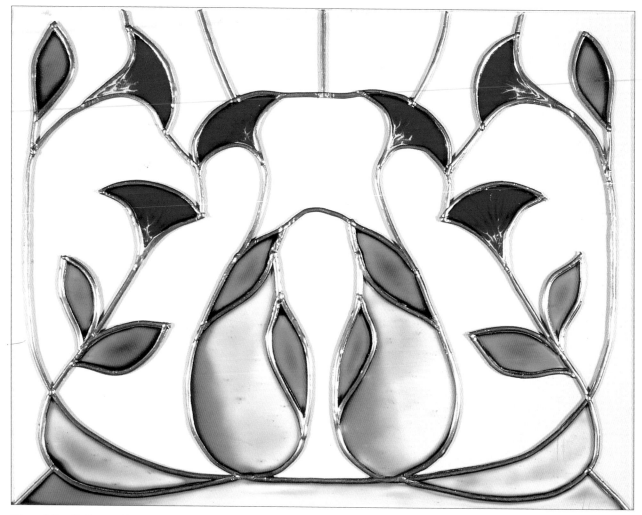

Floral leaded panel

This design, together with the one opposite, is an interpretation of some typical early 20th-century glass work. Notice how the colours in the flowers have been dragged into each other in a similar way to that described on page 41. This panel was painted on plastic sheet and measures 355 x 280mm (14 x 11in). I have included the pattern which must be enlarged to 350% to make a full-size template.

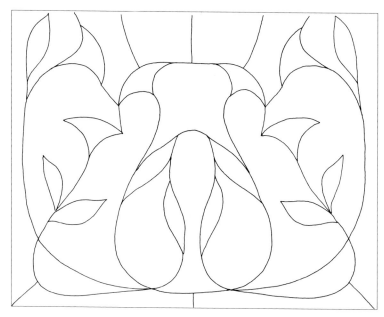

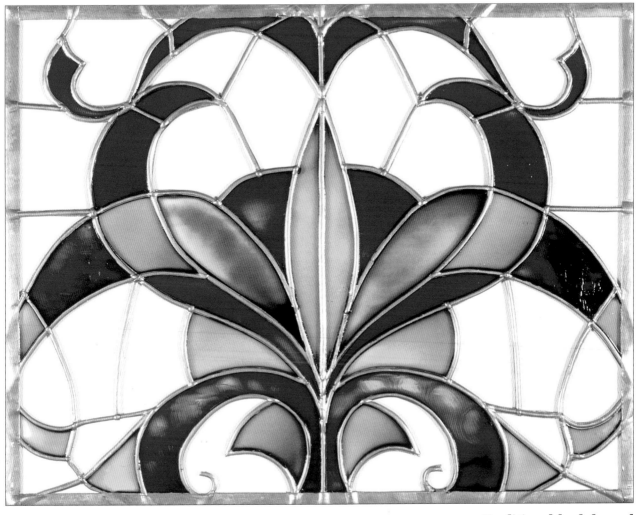

Traditional leaded panel

In this design, I tried to imitate the varying thicknesses of handmade glass by filling some parts with very diluted colour and others with thick neat paint. I hope you agree that this method gives the illusion of genuine stained-glass work. I finished this particular piece with strips of wide lead round the outer edges. This panel was painted on plastic sheet and measures 355 x 280mm (14 x 11in). I have included the pattern which must be enlarged to 350% to make a full-size template.

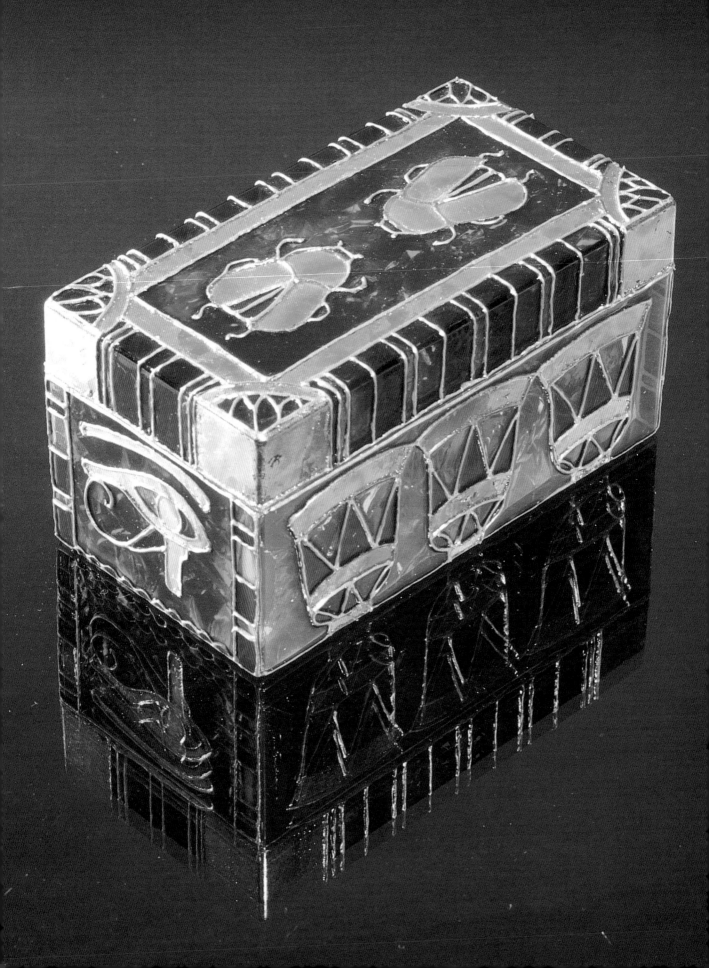

Gilding

Scarab beetle box

Gilding with sheets of Dutch metal leaf contrasts beautifully with the rich colours of glass paints. Initially, metal leaf may appear to be too expensive to consider using. However, it is quite economical as there is no waste and a little really does go a long way. In this project I have used an empty chocolate container as the blank box. It is worthwhile saving any transparent gift boxes you may receive – they are perfect for painting on and they cost nothing.

Dutch metal leaf is an extremely delicate material – so wash your hands before you touch it as any perspiration will make the leaf stick to your fingers.

Materials
The special items you need for this technique are gold size, Dutch metal leaf (which is available in a number of colours) and soft, flat-topped, gilding brushes.

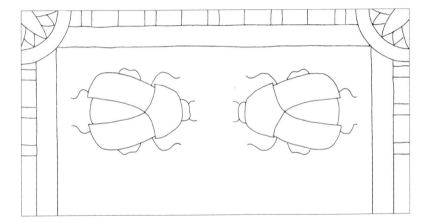

Pattern for the lid.

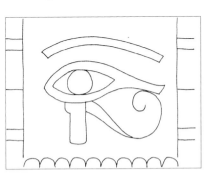

Pattern for the end of the box.

Pattern for the side of the box.

Scarab beetle box
The combination of gold metallic outliner, Dutch metal leaf and glass paints transforms a plain plastic box into a stunning container. I have included patterns for the design which were enlarged to 150% for this particular box. However, you can amend the design to fit a variety of shapes and sizes.

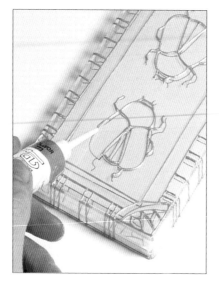

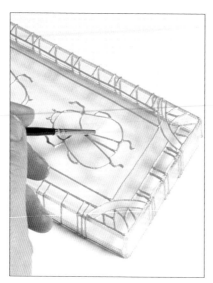

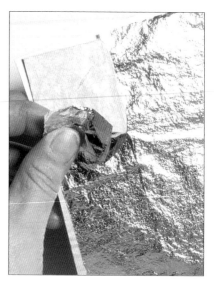

1. Secure a template inside the lid and then use gold metallic outliner to draw the design. Extend the border design down over the sides of the lid. Leave to dry.

2. Now, working on one surface at a time, use a small brush to paint a thin layer of gilding size on all the enclosed areas to be gilded.

3. When the gilding size is dry, tear off a small piece of Dutch metal leaf just large enough to cover the area being gilded.

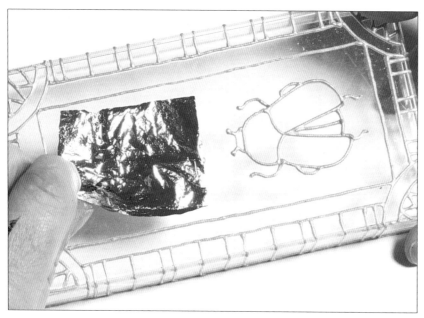

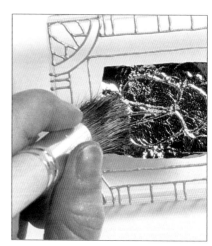

5. Use a large, soft, flat-topped gilding brush to press the leaf down on to the sized design.

4. Carefully place the piece of leaf on the sized area to be gilded.

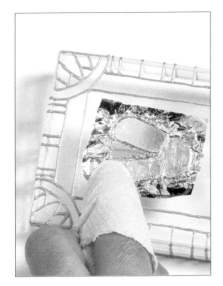

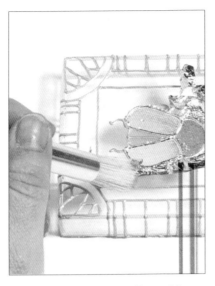

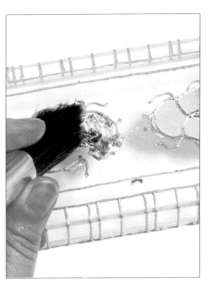

6. Use a soft tissue to smooth out the leaf and give it a flat, shiny appearance.

7. Use a slightly stiffer gilding brush to remove excess leaf from around the edges of the design. Gather all these tiny pieces together.

8. Gently brush the tiny pieces of leaf on to the next sized part of the design.

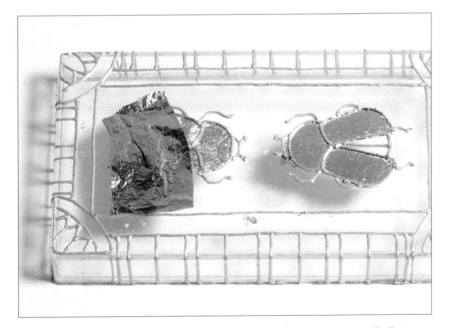

9. Use more leaf to cover bare patches and repeat steps 5–7 to gild this part of the sized design. Gather up and save all excess pieces of leaf. Continue gilding the rest of the design.

10. When all sized areas have been gilded, use a rolled-up piece of masking tape to pick up and remove all unwanted pieces of leaf.

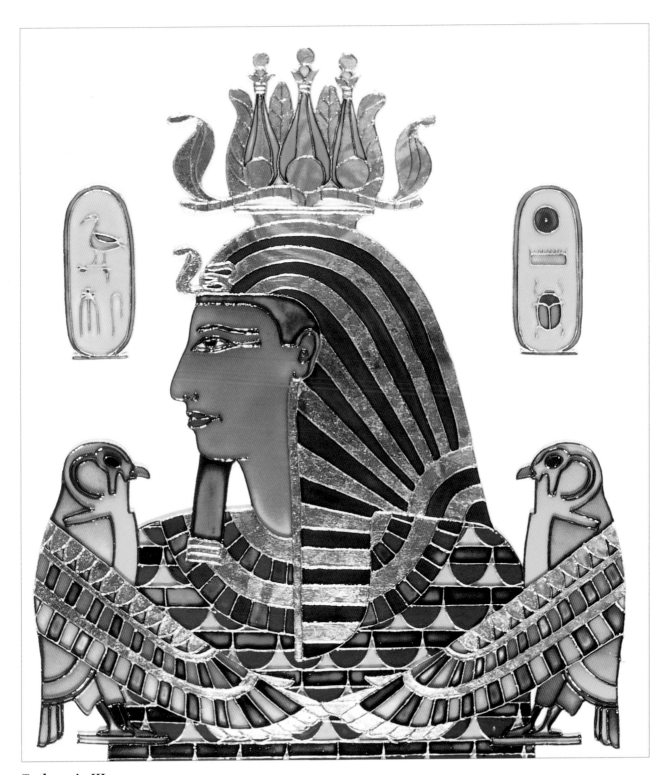

Tuthmosis III

The use of gilding on this pharaoh is reminiscent of the opulence of the ancient Egyptian gold. The panel was painted on plastic and measures 420 x 475mm (16^1/$_2$ x 18^3/$_4$in). Enlarge the pattern to 245% to make a full-size template.

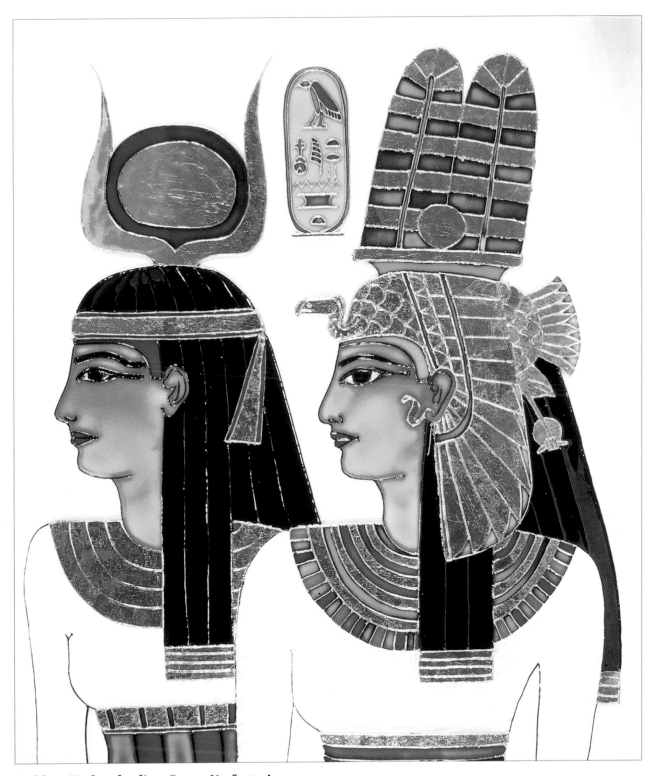

Goddess Hathor leading Queen Nerfertari

The use of gilding on the jewellery and the Queen's vulture headdress really adds to the richness and beauty of this design. The panel was painted on plastic and measures 420 x 475mm (16½ x 18¾in). Enlarge the pattern to 245% to make a full-size template.

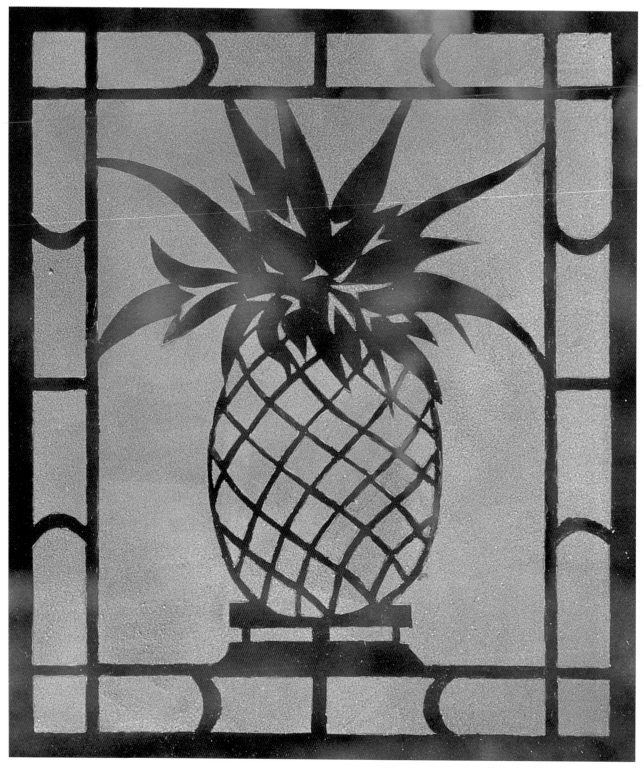

Frosted pineapple
This panel is painted on glass and the frosted design
measures 345 x 405mm (13¹/₂ x 16in).

Stencilling

Frosted pineapple

In this chapter I show you how to recreate the classic textured acid-etched finish on window and door panels, using simple stencils and frosting varnish.

It is easy to cut your own stencils, and homemade ones cost a fraction of proprietry ones. I have included two designs for you to try, but you can also use some of the other designs in this book as well. In this project I have cut a stencil to frost the background areas but there is no reason why you could not amend the design slightly to produce a reverse effect.

Materials

For this project you will need some thin acetate, some frosting varnish, pieces of sponge, a pair of scissors, and some double-sided sticky tape or low-tack adhesive spray.

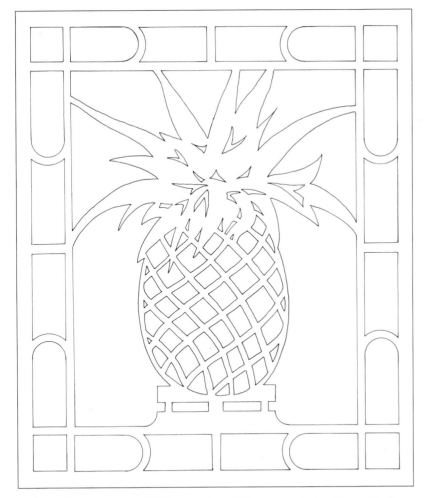

Enlarge the pattern to 340% to make a full size template. Alternatively, enlarge the central image to a suitable size for your panel and draw your own border design.

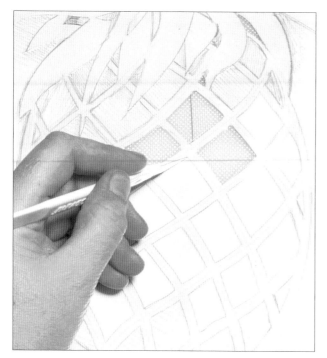

1. First make your stencil. Secure a sheet of thin acetate over the template and then use a craft knife to cut out the areas to be frosted. Work carefully and make neat cuts in tight corners – repair any splits with clear sticky tape.

2. Fix small pieces of double-sided sticky tape on the back of the stencil. Alternatively, apply a low-tack spray adhesive.

3. Fix the stencil to the glass. Gradually remove the backing from the pieces of tape and roll the stencil into position.

4. Decant the frosting varnish into a large palette and use a fine sponge to apply a generous layer all over the stencil.

5. While the varnish is still wet, use a dry, firm sponge to create an etched texture. Press the sponge firmly down on to the glass . . .

6. . . . and then lift the sponge straight off. Work quickly across the whole design, applying even pressure with the sponge to create a uniform finish.

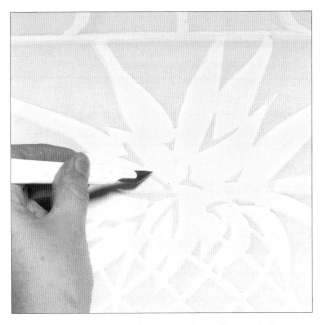

8. Use a scalpel to clean up the edges of the design if necessary.

7. When you are happy with the texture, and while the frosting varnish is still wet, carefully remove the stencil and the pieces of double-sided tape from the design. Allow the varnish to dry.

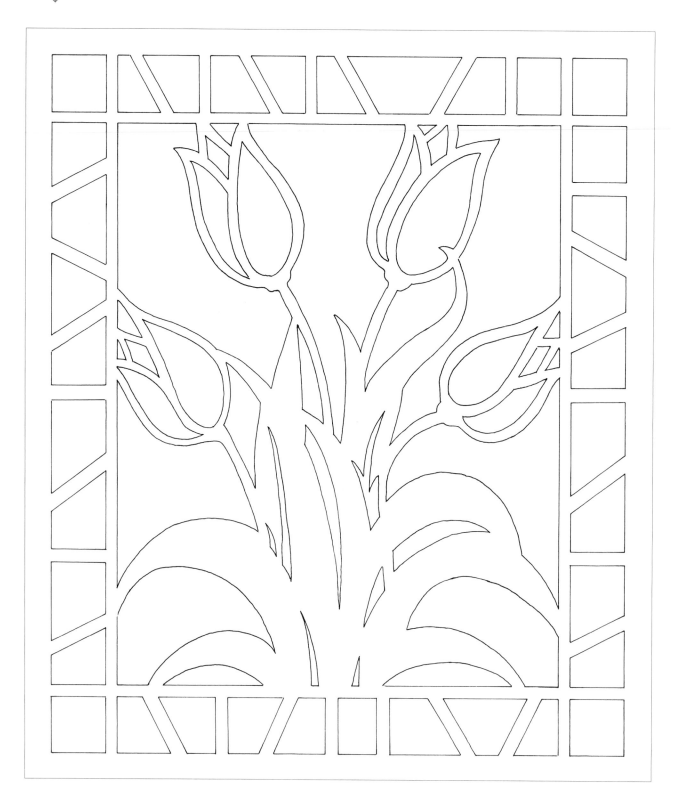

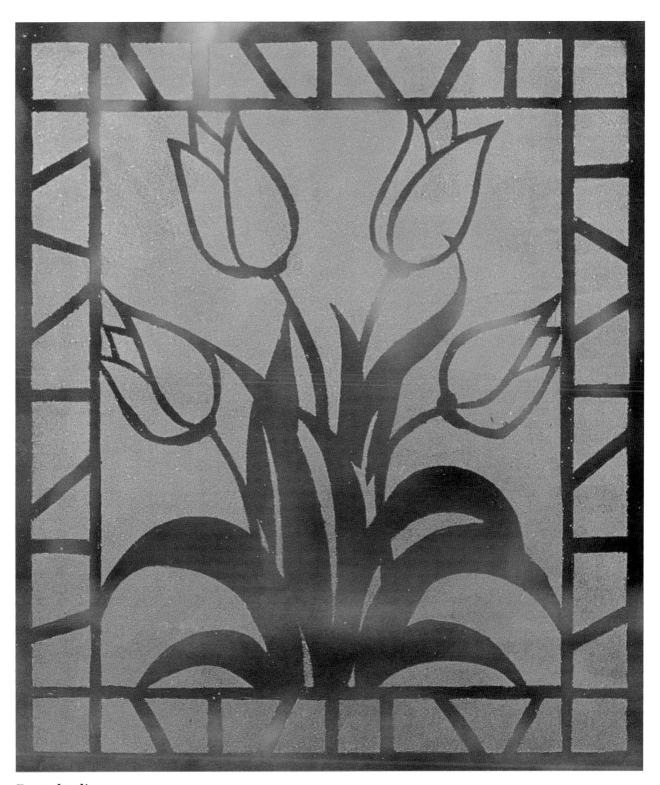

Frosted tulip
This panel is painted on glass and the design measures 345 x 405mm
(13¹/₂ x 16in). Enlarge the pattern to 215% to make a full-size template.
Alternatively, size the tulip design to fit your panel and add your own border.

Using gel

Geometric floral panel

Gel is a very versatile medium that can be used to create many different effects. It can be painted on with a brush for subtle textured effects. It can be piped with a nozzle for thick lines of colour. It can be applied with a palette knife and then left chunky or smoothed over. It can also be used in conjuction with outliner. When the gel is dry, it can be painted over with ordinary glass paints to create interesting shades of colour.

Materials
For this project you will need a selection of gel paints, a nozzle and a spatula.

Geometric floral panel
This project is painted on acetate and measures 210 x 297mm (8¹/₄ x 11³/₄in). Enlarge the pattern to 200% for a full-size template. The background is developed freehand – use your new-found skills to develop your own ideas.

1. Snip the tip off the end of a plastic nozzle, and attach the nozzle to a tube of gel. Make sure the nozzle is screwed on firmly, or gel may ooze out through the seal.

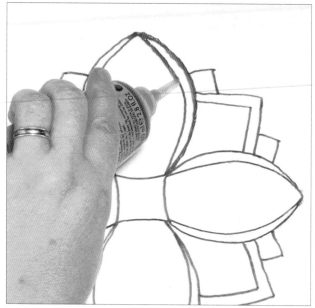

2. Attach a sheet of acetate over the template and then wipe the surface of the acetate with glass cleaner. If the acetate is not completely clean, the gel may not adhere properly, and it may lift at the edges when it is dry.

3. Vigorously shake the tube of gel to thoroughly mix the contents. If you do not do this, the gel will initially be very watery. Leave the tube to stand for a few minutes and then pipe the outline of the design. Leave to dry.

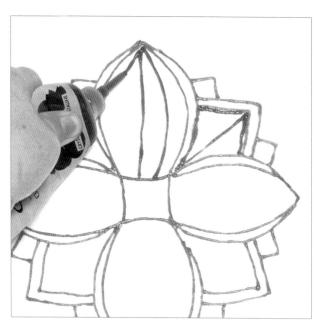

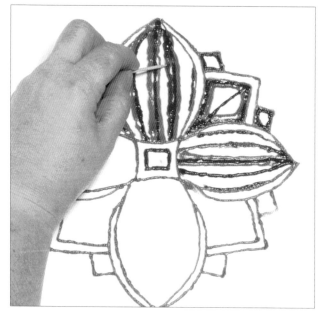

4. When the outline is complete, remove the template and then start to fill in each petal with curved lines of gel.

5. Continue building up lines of gel on the petals using colours of your choice. If you leave any gaps, use a cocktail stick to push the line of gel up against the previous one.

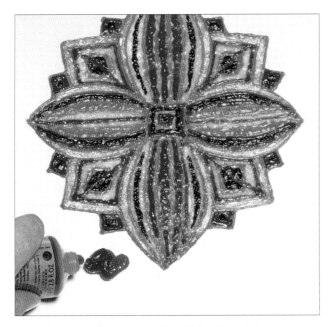

6. When you have completed the floral design, leave until the gel is touch dry. Now start to work the background. For this project, remove the nozzle from the tube and squeeze large blobs of gel on to the background area.

7. Use a palette knife to spread the gel across the acetate. Try to achieve a reasonably smooth layer all over the surface.

8. Use the flat end of the palette knife to pat the gel and create a random textured pattern.

9. If you are not happy with the design, simply smooth the gel flat and start again.

10. Use the edge of the palette knife to draw oblique lines in the gel to form a chevron design at the top and bottom of the picture.

11. When you have finished filling in the complete design, leave the gel to dry completely. Sometimes the gel will shrink and/or lift slightly – make repairs by piping on more gel and then leaving it to dry again.

12. Finally, add more interest to the design by applying ordinary glass paint over the dry gel.

Opposite:
Bottle and vases
Gel is a very versatile medium, and here are a few other items that I have decorated using it.

I piped clear gel in a simple random design all over the surface of the bottle.

I applied bands of coloured gel round the small vase. Then, while the gel was still wet, I used a palette knife to impress the pattern.

I achieved the stippled effect on the bottom half of the large vase by applying gel with a large brush and a dabbing action. I applied a thick layer of gel round the top of this vase then left it to set for 15–30 minutes, until it was touch dry on the surface but still wet underneath. I then pressed the glass beads in place. If you try placing the beads too soon their weight will cause them to slide out of position.

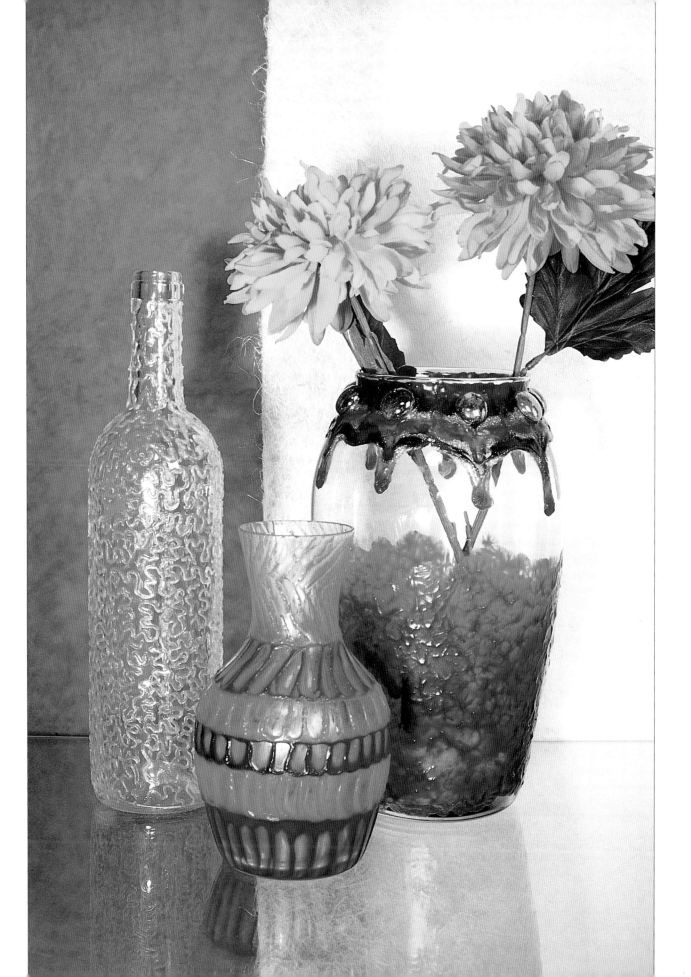

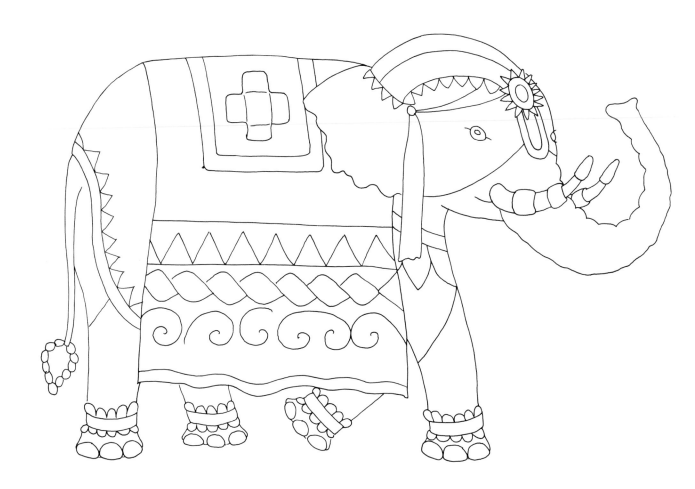

Enlarge these patterns to 170% to make full-size templates.

Elephant panel

This gel picture is painted on a 400mm (16in) square plastic panel.

I wanted the panel to have the appearance of an old Indian batik print, so I first selected a palette of rich reds, gold and black.

I started with the elephant and drew its outer shape and the cloth on its back, with black outliner. Then I used a large soft brush and a dabbing action to apply gel to the elephant's body.

Next, I worked on the Maharajah and traced all the lines with outliner. I filled in this part of the design with both glass paints and gel, using a brush and a nozzle. I worked the pattern on the backcloth with piped lines of gel. When the gel was completely dry, I added finishing touches with gold metallic outliner.

The border was then added. I drew the design with black outliner and, when this was dry, I piped gel in each enclosed area.

Finally, I filled in the background with red gel. I used a palette knife to create a rough texture and then painted over this with a much deeper red, diluted 50/50 with water. The overpainting allowed a lot of the original gel colour to show but gave it a mottled appearance.

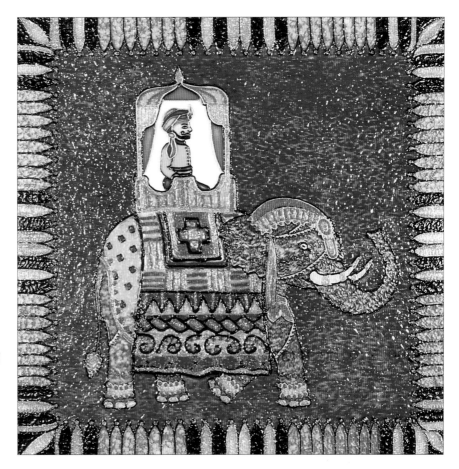

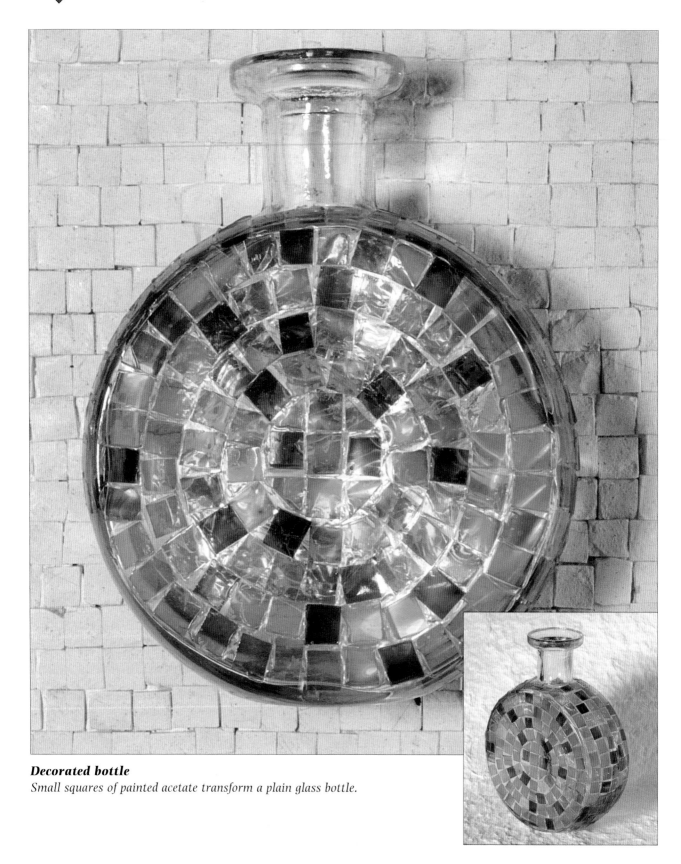

Decorated bottle
Small squares of painted acetate transform a plain glass bottle.

Mosaic designs

Decorated bottle

This is a fun method of using up scrap pieces of acetate to transform virtually anything into a beautiful mosaic design. You only need to paint acetate sheets with ordinary glass paints, cut them up into small squares and then position them on to a surface covered with clear gel. It is so easy, anyone can do it!

Here, I show you how to transform a plain glass bottle but the technique also works very well on flat panels (see page 71).

Materials
To create mosaics you will need a tube of clear gel, a palette knife, a pair of scissors and some wooden cocktail sticks.

1. Paint pieces of acetate with your chosen colours and leave to dry. Do not worry about getting a perfect finish as variations in colour will add interest to the finished mosaic.

2. Use a sharp pair of scissors to cut the painted pieces of acetate – first into strips and then into small squares.

3. Apply a fairly thick layer of clear gel on to the bottle.

4. Use a palette knife to spread the gel over the surface.

5. Use a damp paint brush to pick up individual squares of painted acetate and gently position them on the gel.

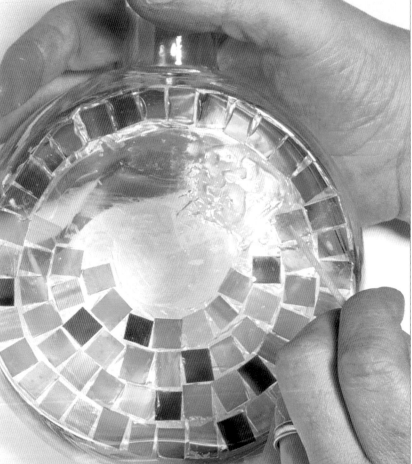

6. Use a cocktail stick to press the square of acetate into the gel. The gel should ooze out slightly between the squares.

7. Continue placing and pressing the pieces of acetate in a random mosaic pattern. When the flat surfaces of the bottle are complete, leave to dry. Work the curved surfaces in a similar way.

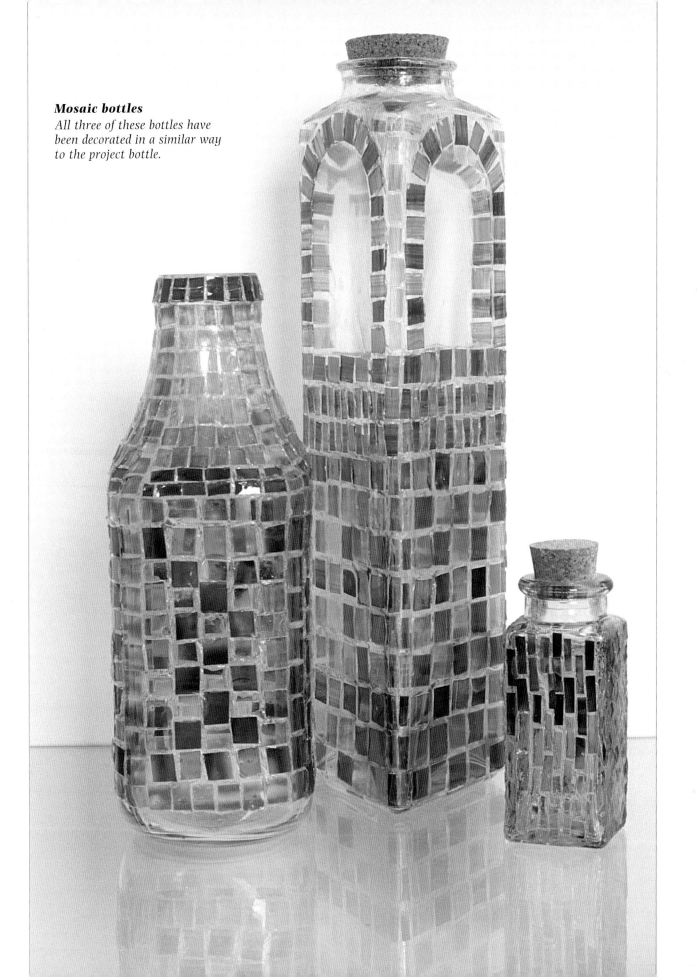

Mosaic bottles
All three of these bottles have
been decorated in a similar way
to the project bottle.

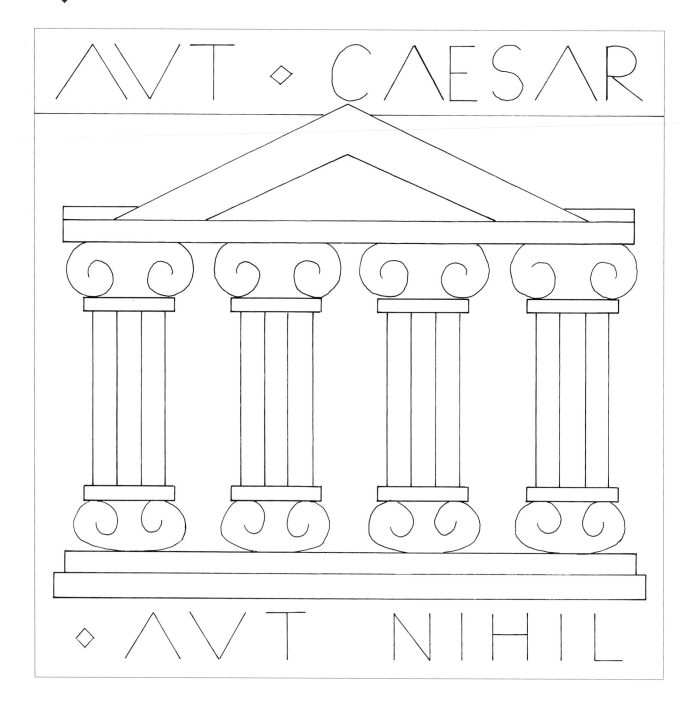

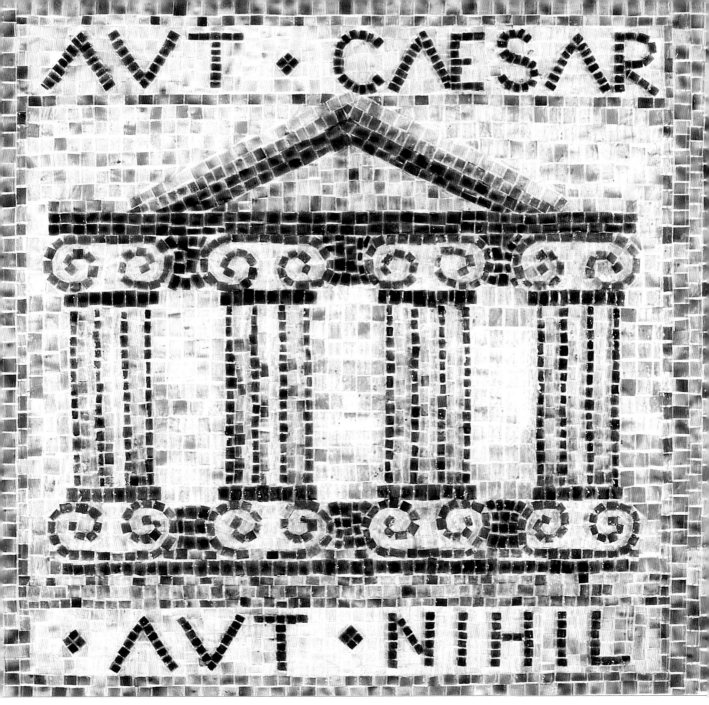

Roman temple

Roughly translated, Aut Caesar, Aut Nihil, means All or Nothing!

A large project such as this Roman temple requires a template, a colour plan and a more regimented placement of the mosaic pieces. I worked from the centre outwards, building up the temple, then the lettering and finally the border. It may not be possible to finish such a large project at one sitting. When you want to have a break, make sure that you wipe all gel from unworked areas to leave the surface smooth for when you wish to continue adding mosaic pieces.

This picture is assembled on a sheet of plastic that measures 470 x 420mm (18½ x 16½in). I have included the pattern for the temple and the lettering, which must be enlarged to 240% for a full-size template.

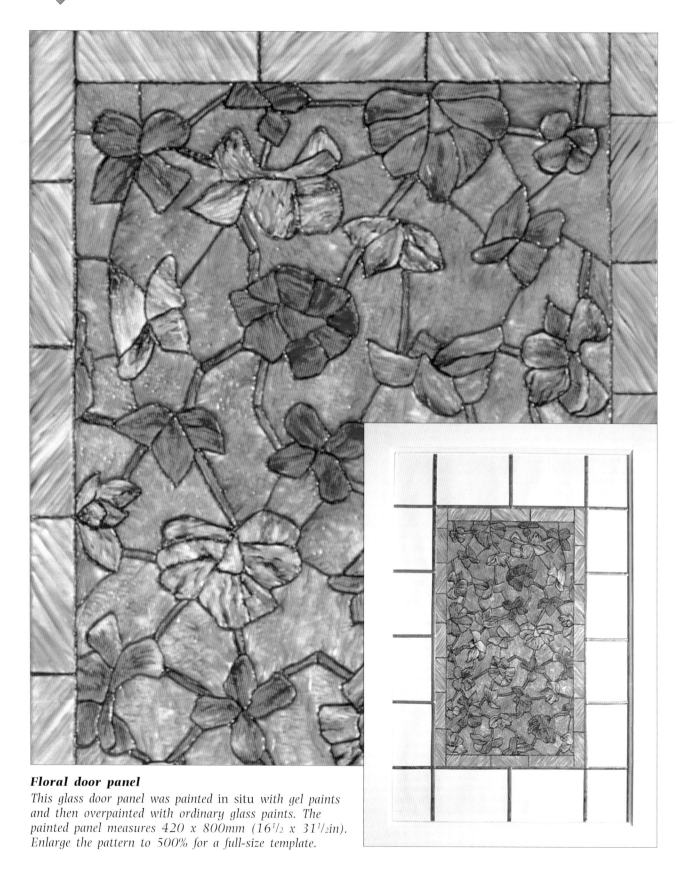

Floral door panel

This glass door panel was painted in situ with gel paints and then overpainted with ordinary glass paints. The painted panel measures 420 x 800mm (16$^{1}/_{2}$ x 31$^{1}/_{2}$in). Enlarge the pattern to 500% for a full-size template.

Window panels

Floral door panel

Whenever I hold workshops or demonstrate at exhibitions, the question I am asked most often is 'Can I paint my own windows and doors at home?' The answer is a definite yes!

In the first project, I show you, step by step, how to paint on a vertical surface – a window or glazed door *in situ*. Then, I show you how to fix painted panels to existing glass, including a method for use with UPVC windows and doors – so, if you ever move house, you can take your beautiful paintings with you! Finally I show you how fix a chain to a painted panel so that it can be hung against a window.

Materials

The materials required for the door panel project are self-adhesive lead, a burnishing tool, gel paints, wooden cocktail sticks, a felt-tip pen or chinagraph pencil, a pair of scissors and masking tape. For fixing panels in existing windows you will also need some wooden beading and panel pins, or picture clips and a length of chain.

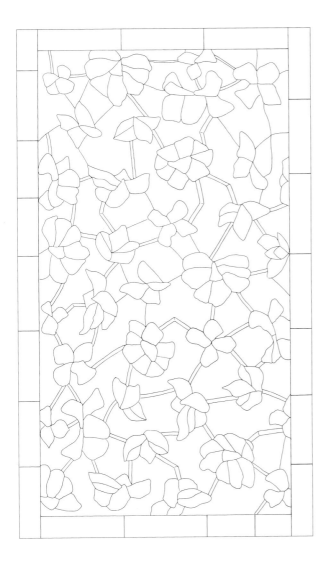

1. Mark the position of the corners of the design on the glass with a felt-tip pen or chinagraph pencil.

2. Fix the template to the rear of the window and draw straight lines to show the positions for the self-adhesive lead strips of the outer border.

3. Cut short lengths of lead and stick the vertical ones to the glass just short of the long horizontal guide lines at the top and bottom of the window panel. Secure the short horizontal lengths down each side in a similar way.

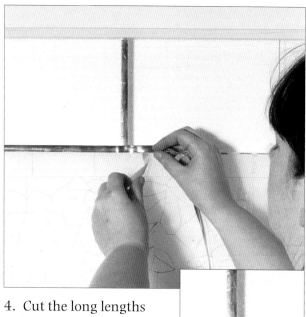

5. Use black outliner to draw the floral design. Rest your hand against the glass to give support.

4. Cut the long lengths and position them. Lay in the two horizontal lengths first, securing them just off the drawn guide lines. Lay in the two long vertical lengths of lead in a similar way. Burnish all overlaps to make neat joints.

6. Protect the leading round the outer edges of the central design with strips of masking tape.

7. Remove the template and paint the design with gel. Use coral gel for the petals.

8. Overpaint the coral gel with scarlet glass paint to add tone.

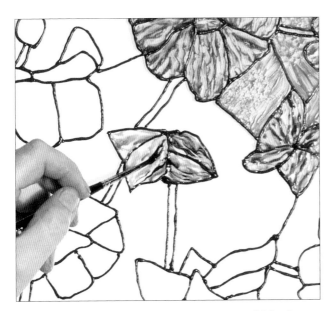

9. Use white gel and golden yellow and black glass paint to colour some of the other flowers. Paint an initial layer of colours over the design using a light covering of paint to stop any runs. Leave to dry and then add more paint to increase the density of colour as necessary.

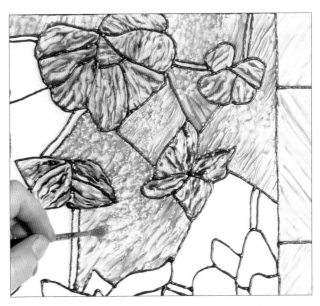

10. Use blue gel to fill in the background areas. Apply short strokes with the brush to give a textured effect. Use a similar technique and turquoise gel to fill in the border.

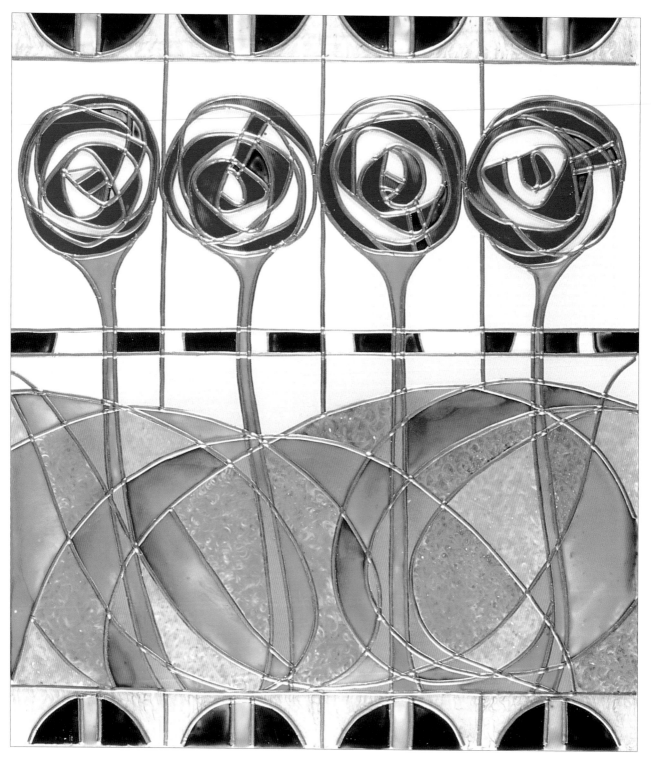

Roses

This interpretation of Mackintosh's glass work would be stunning as a front door panel, but it would look equally well as a hanging panel (see page 79). To achieve an authentic looking stained-glass appearance, I have combined self-adhesive lead, ordinary glass paints and gel which was applied with a brush. The plastic panel measures 400 x 460mm (16 x 18in). Enlarge the pattern to 230% for a full-size template.

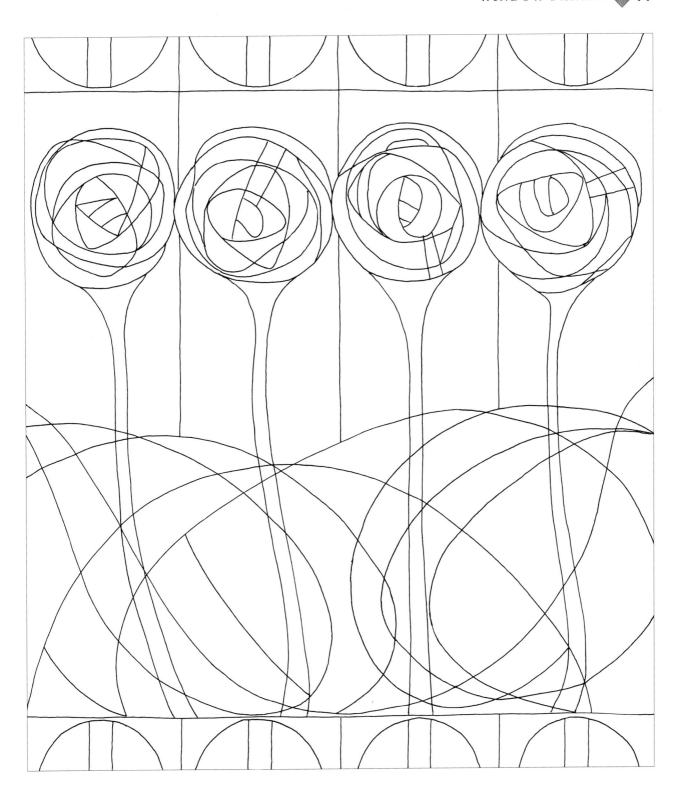

Fixing a panel on to a vertical window

Glass paintings can be fixed on to an existing window using 12mm ($\frac{1}{2}$in) wide strips of self-adhesive lead. I recommend that the dimensions of the glass do not exceed 400 x 300mm (16 x 12in). Use only lightweight picture glass. Ensure the glass is clean and dry, as any condensation will prevent the lead adhering properly.

1. Position the panel on the window, with the painted side facing the glass, and then secure it in place with three strips of strong masking tape. Do not tape the right-hand vertical edge.

2. Measure the sides of the panel and cut strips of self-adhesive lead oversize to allow 12mm ($\frac{1}{2}$in) overlaps at each end. Start at the right-hand side of the panel and apply a length of lead. Use the burnishing tool to press the lead firmly in place. Half the width of the lead should adhere to the existing window. Remove the masking tape from the left-hand side and stick the second short strip of lead in place.

3. Remove the strip of tape from the top edge and stick a long length of lead along this edge. Repeat along the bottom edge. Finally go over all joins with the burnishing tool and trim the corners to make a neat finish.

Using wooden battens

A panel to be fitted to an existing window should be the same size as the exposed area of glass in the window. Measure the glass and mitre the ends of wooden beading to size. Hold the panel in position against the glass, with the painted side facing away from you. Use veneer pins to secure the strips of beading to the window frame.

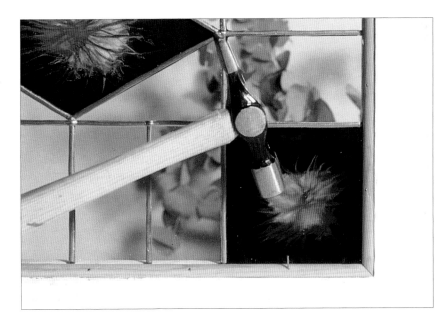

Fixing hanging clips

Picture hanging clips such as the ones shown here are available from most DIY stores. They can be secured to paintings with self-adhesive lead strip so that your paintings can be hung in a window, rather than fastened to it. Use only with plastic panels as the assembly may not bear the weight of glass.

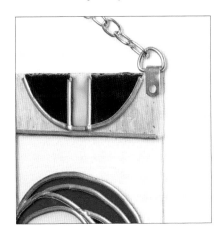

1. Cut the chain to length and fix to the clips. Prize open the clips and press them on to the top corner of the glass.

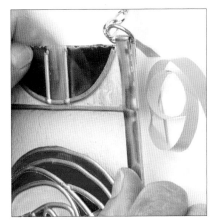

2. Cut lengths of self-adhesive lead 25mm (1in) longer than the vertical sides of the panel. Fix a strip along one side and pass the excess through the loop of the clip. Turn the end down on to the back of the panel. Repeat for the other short edge.

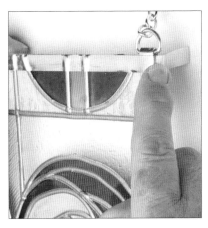

3. Cut another length of lead 50mm (2in) longer than the top edge. Stick this along the top edge of the panel and turn the ends over on to the back of the glass. Burnish all overlaps.

Index